Highgate Cemetery

Photographs by
JOHN SWANNELL

Sold by Highgate Cemetery Limited on behalf of
Highgate Cemetery Trust (registered Charity 1058392)
to support continuing conservation work at the Cemetery.

First published in November 2010 by Hurtwood Press
31 Station Road West, Oxted, Surrey RH8 9EE, Great Britain

ISBN 978-0-903696-34-0

Highgate Cemetery

Photographs by
JOHN SWANNELL

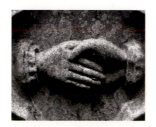

The Friends of Highgate Cemetery Trust

INTRODUCTION

John Swannell is going to be buried in Highgate cemetery. He purchased a plot some time ago, a clear indication of his pure romantic character.

He was born in 1946. It should have been 1839 when the cemetery came into being, for John was born out of time. His true self belongs to the Pre-Raphaelite Brotherhood, formed, like the cemetery, in the nineteenth century.

Rossetti's women are what possibly connected John to the romantic ideal of women. The pale complexion, the flowing hair, the whole melancholy atmosphere that surrounds these women; totally different from today's television showing girls behaving very badly. But the girlfriends of the brotherhood were up for drugs (laudanum) and a bit of boyfriend-swapping and, sadly, suicide. It was not so romantic for Rossetti to dig up his wife's grave to get back the poems he had lovingly buried with her as a token of his love. This act adds to the fascination of Highgate cemetery. The rumours, the prestige of Karl Marx being buried there, the gravestones, the Gothic, the Egyptian … the whole theatre of the place is a time warp of Victoriana.

John, with his obsession for the romantic, is the perfect person to document this extraordinary place with his camera, adding another chapter to the living history of a place for the dead.

David Bailey
London 2010

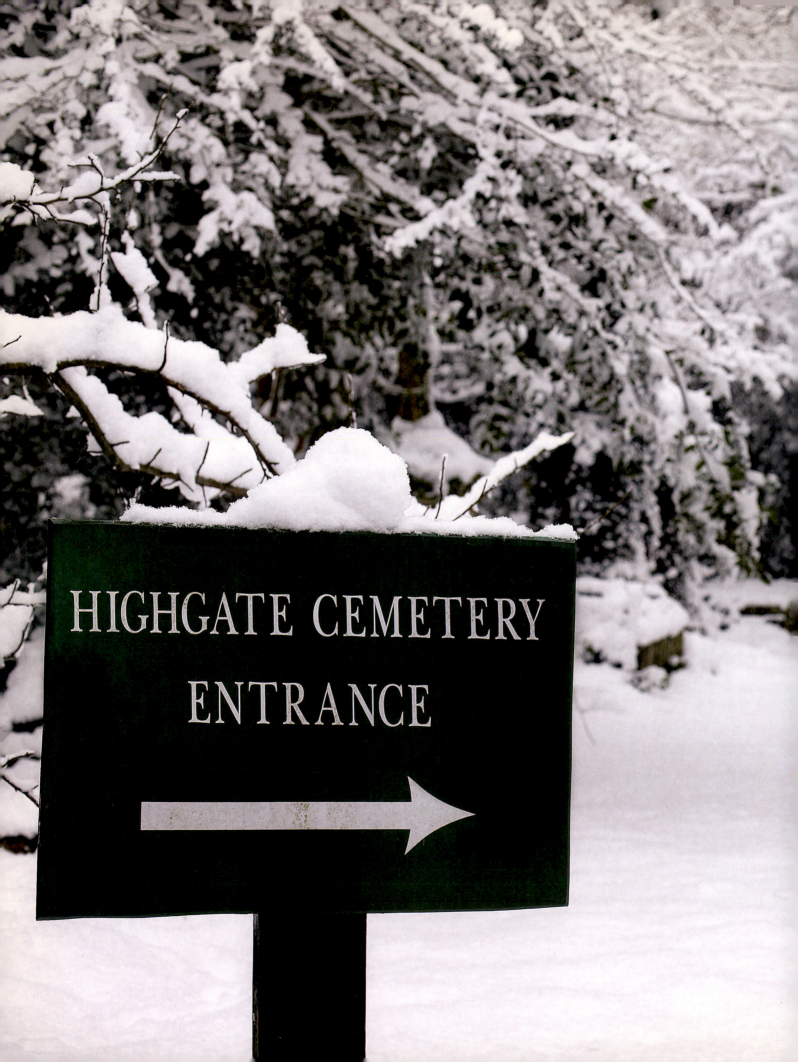

HIGHGATE CEMETERY
ENTRANCE

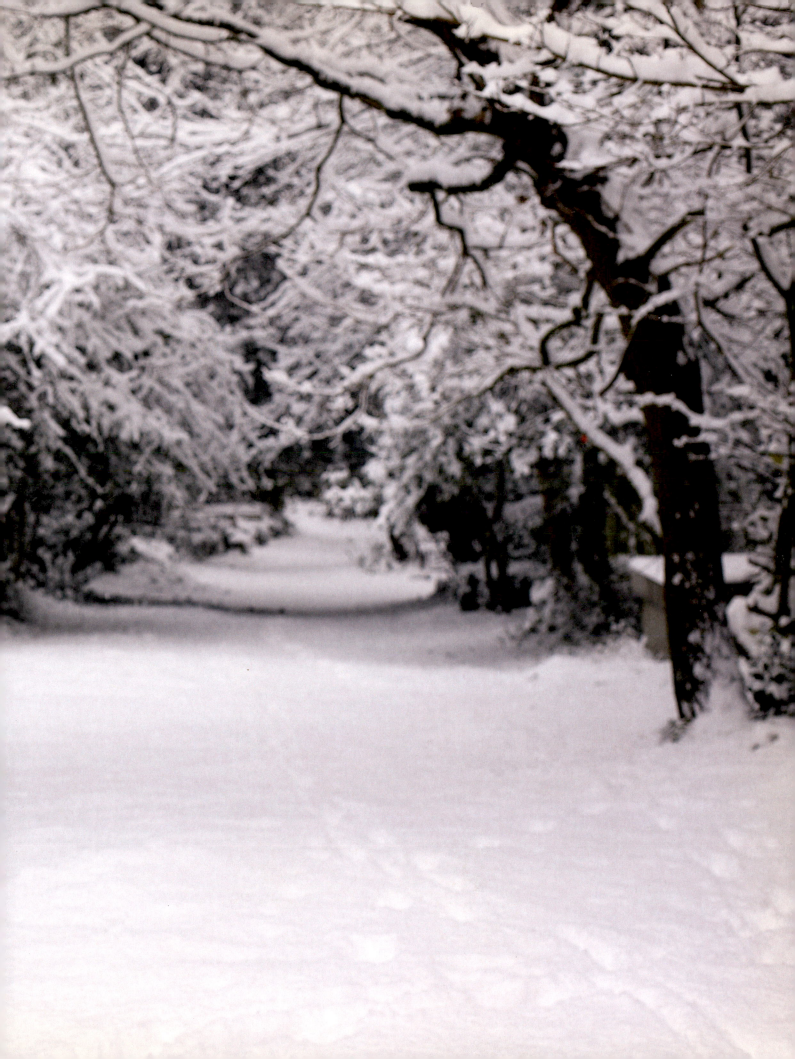

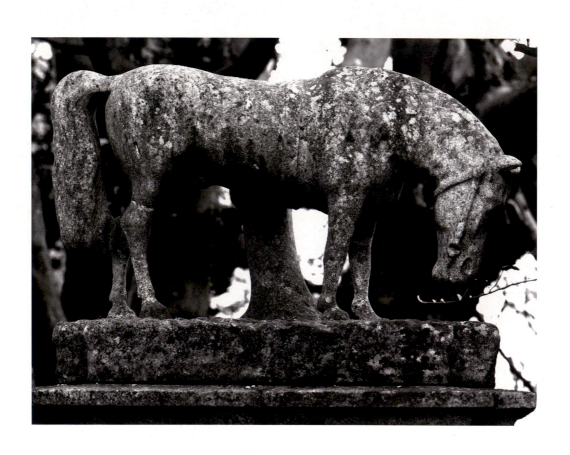

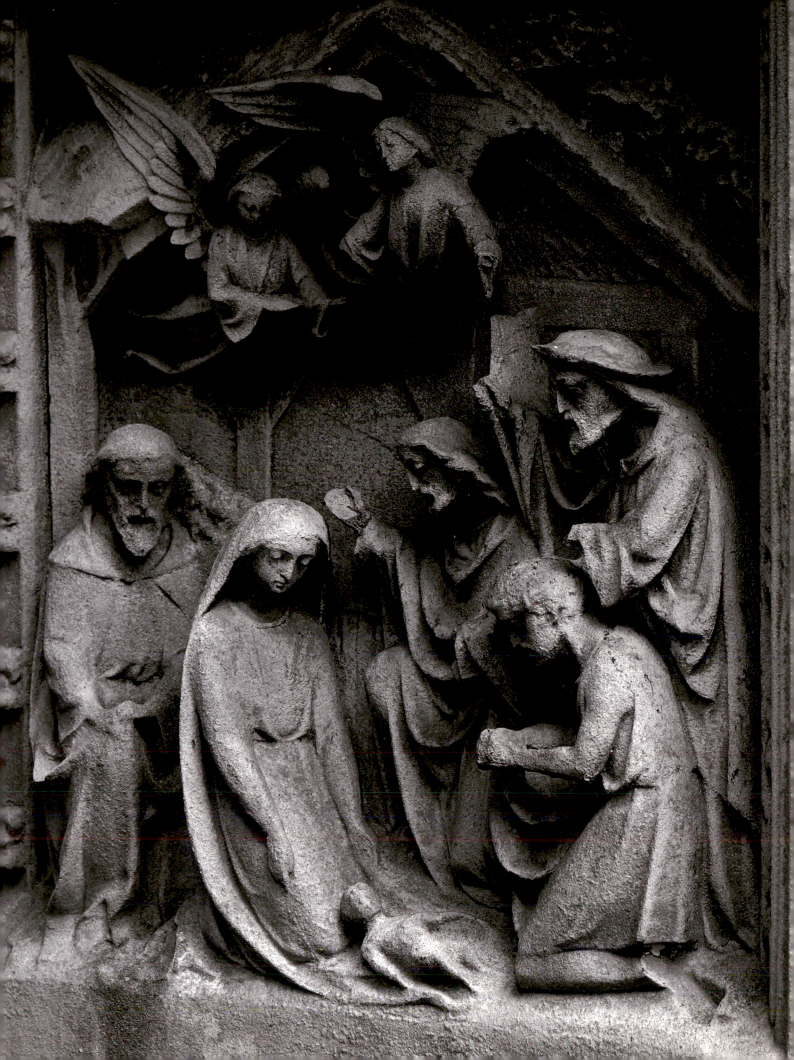

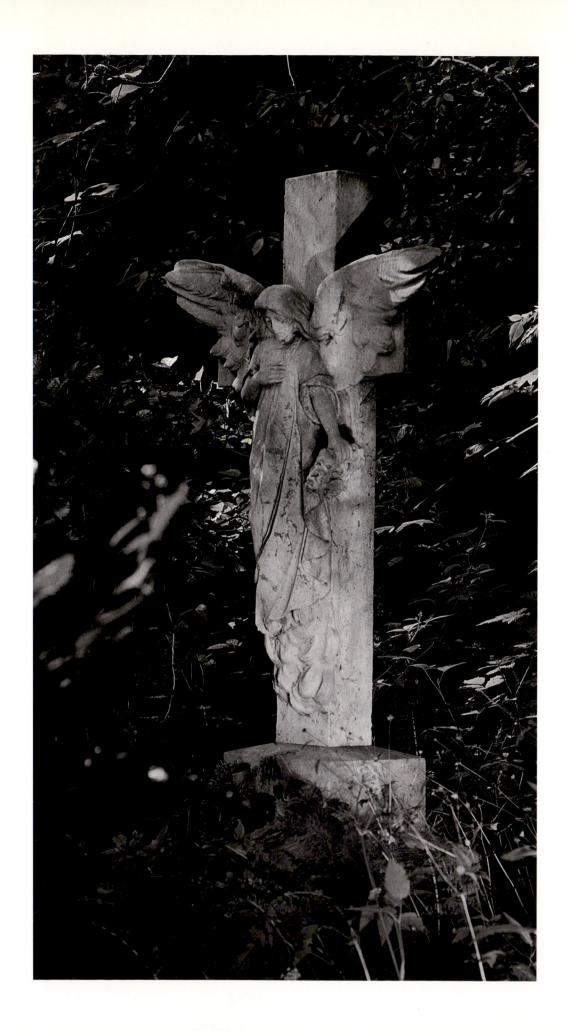

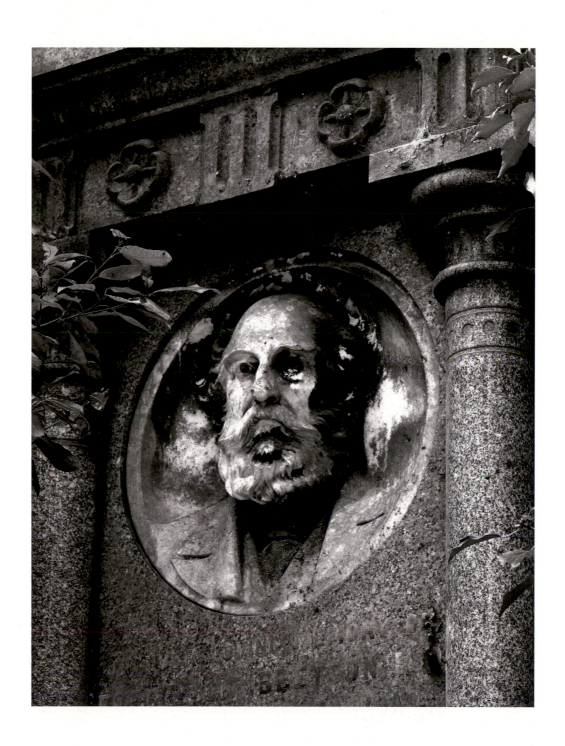

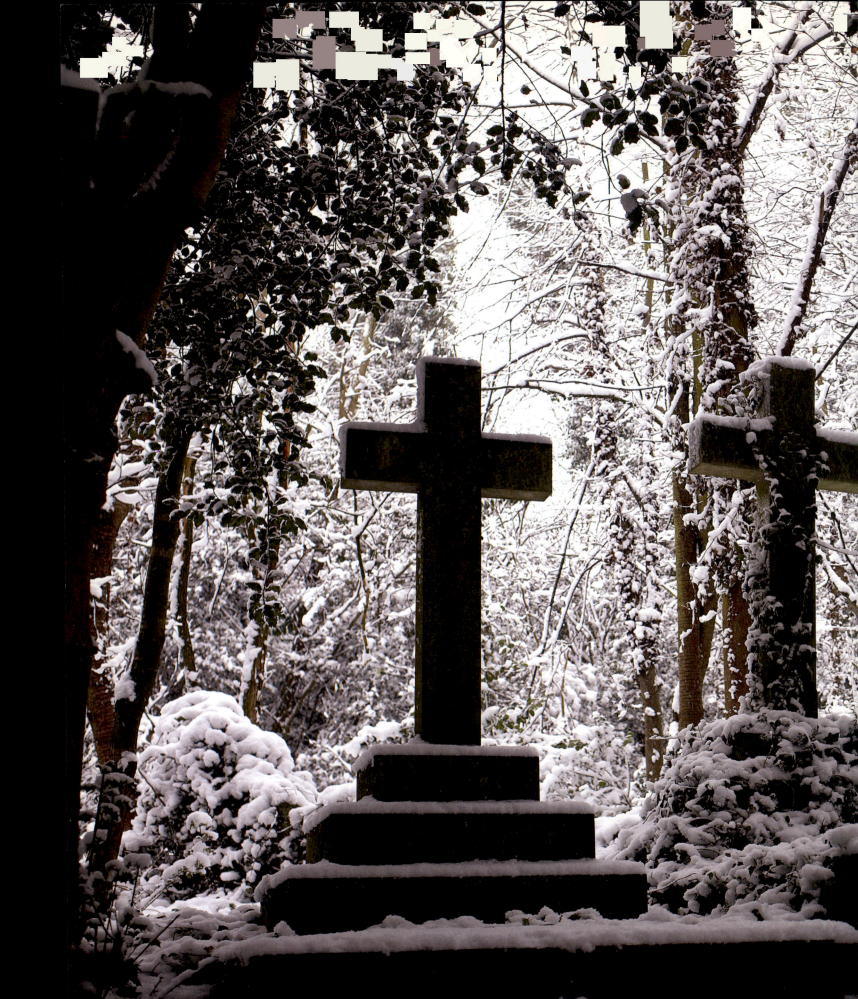

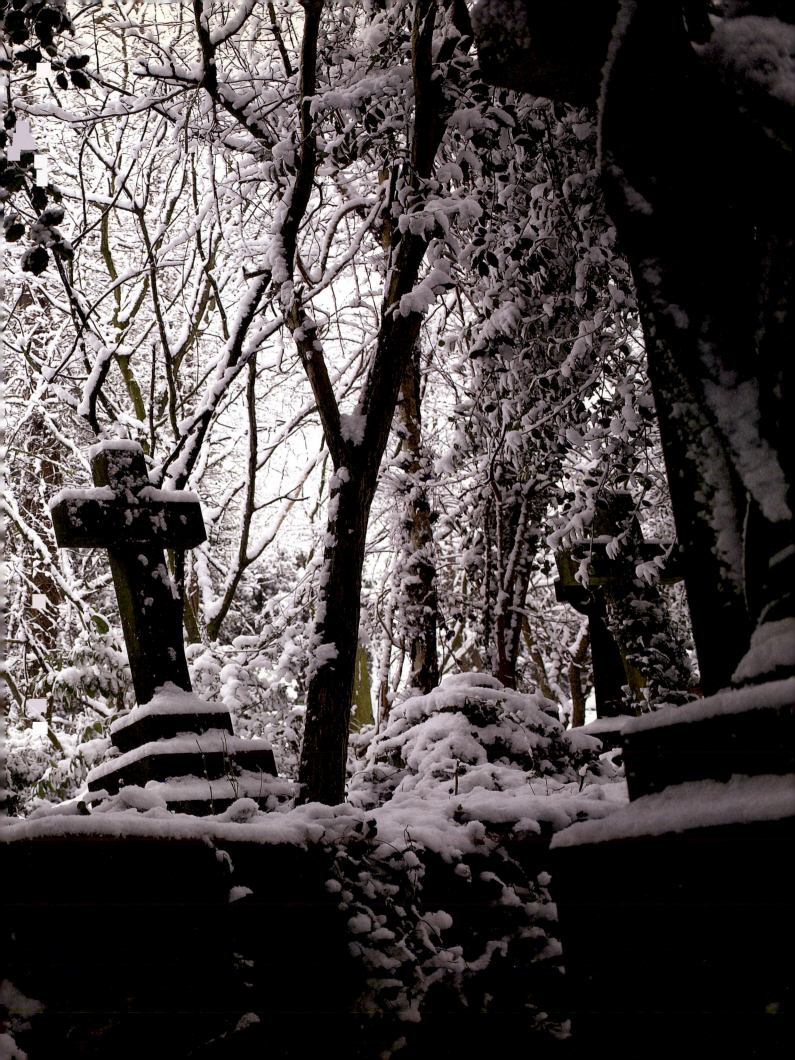

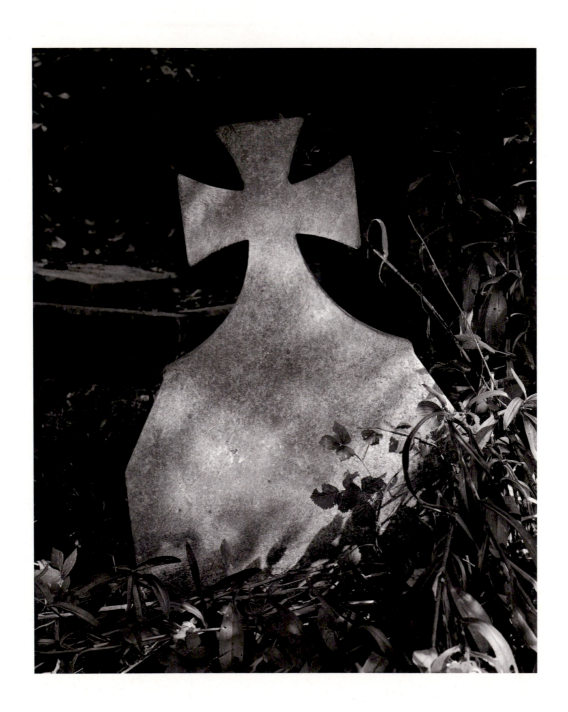

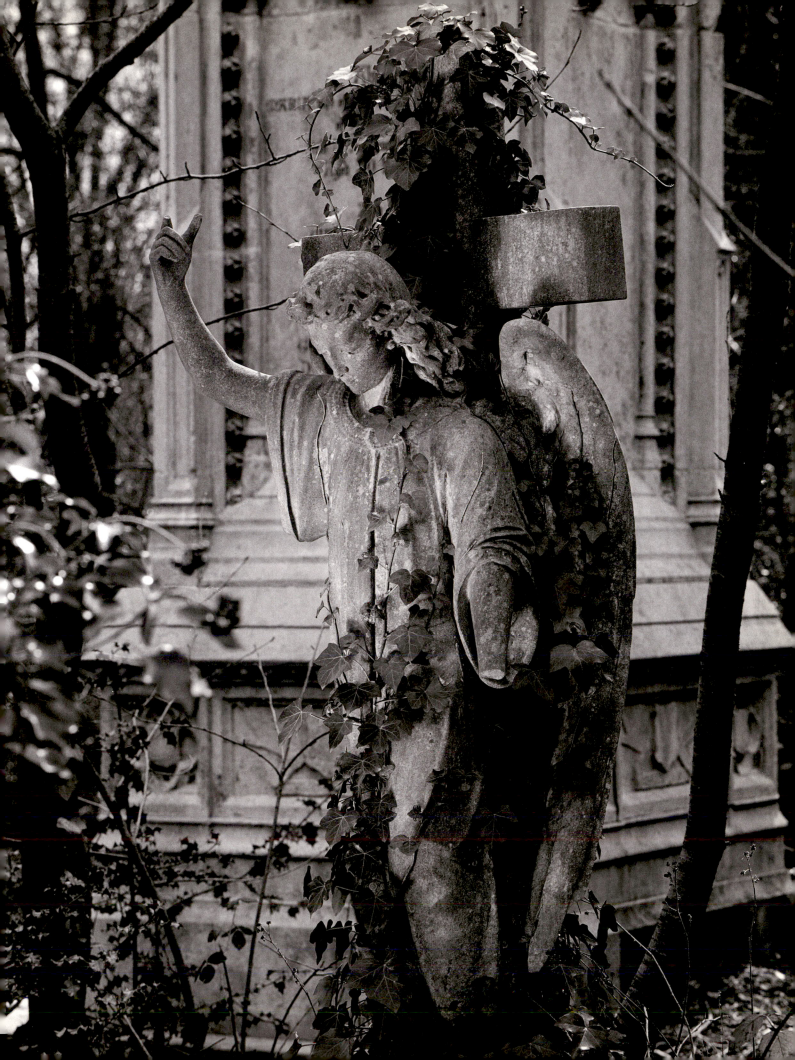

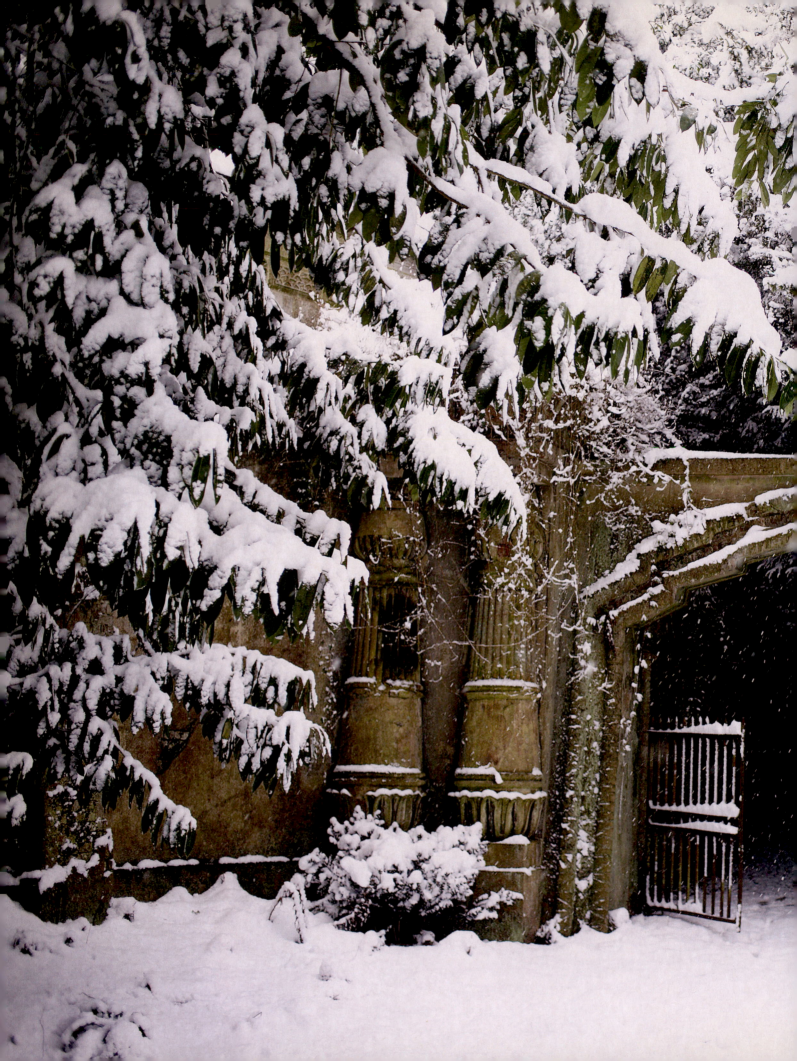

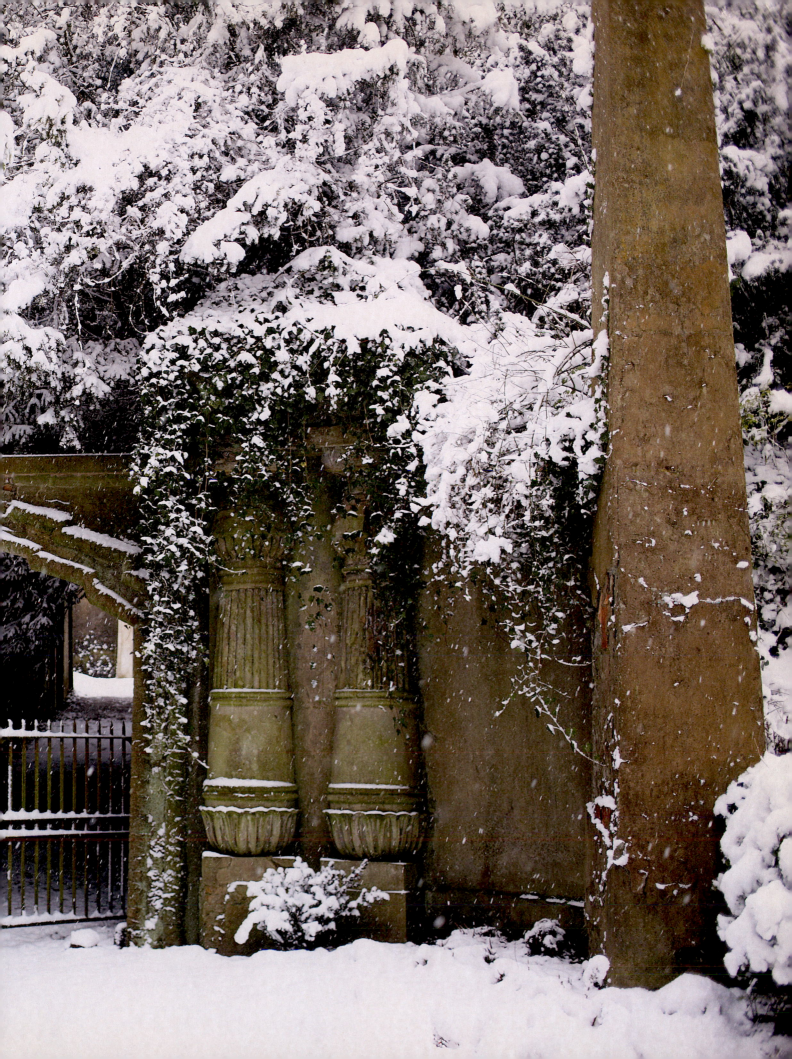

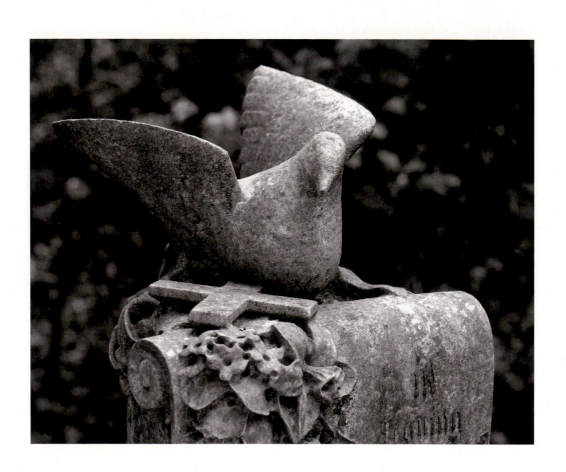

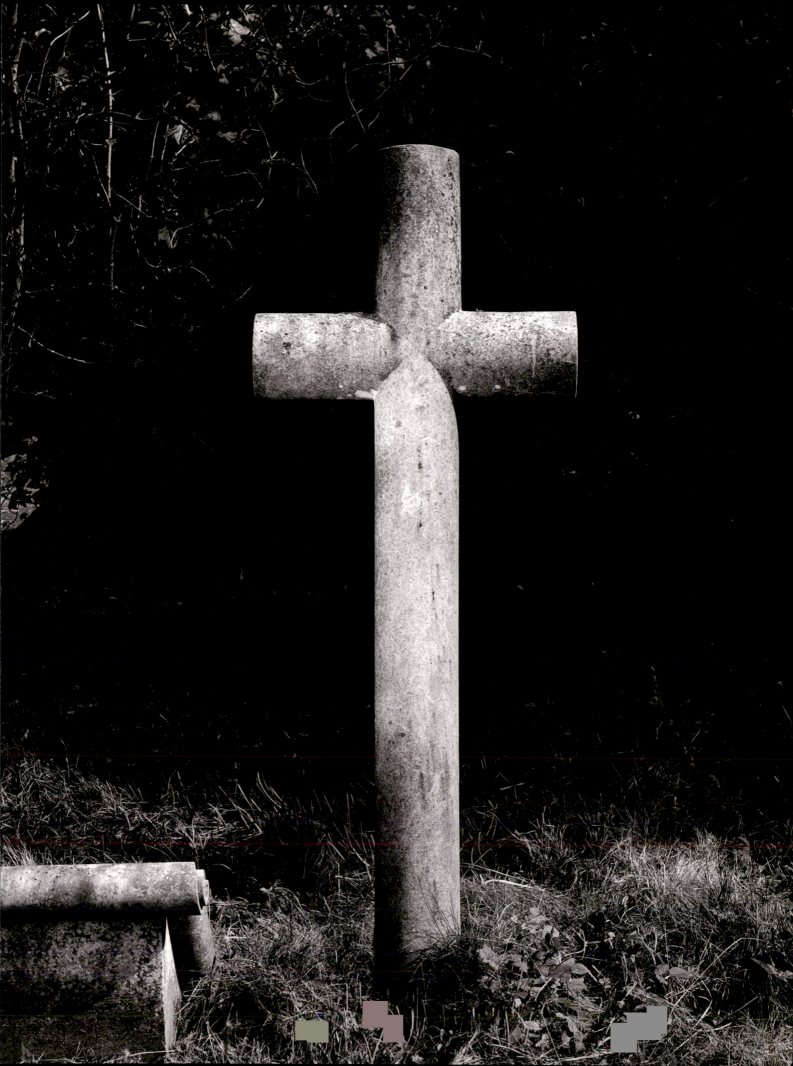

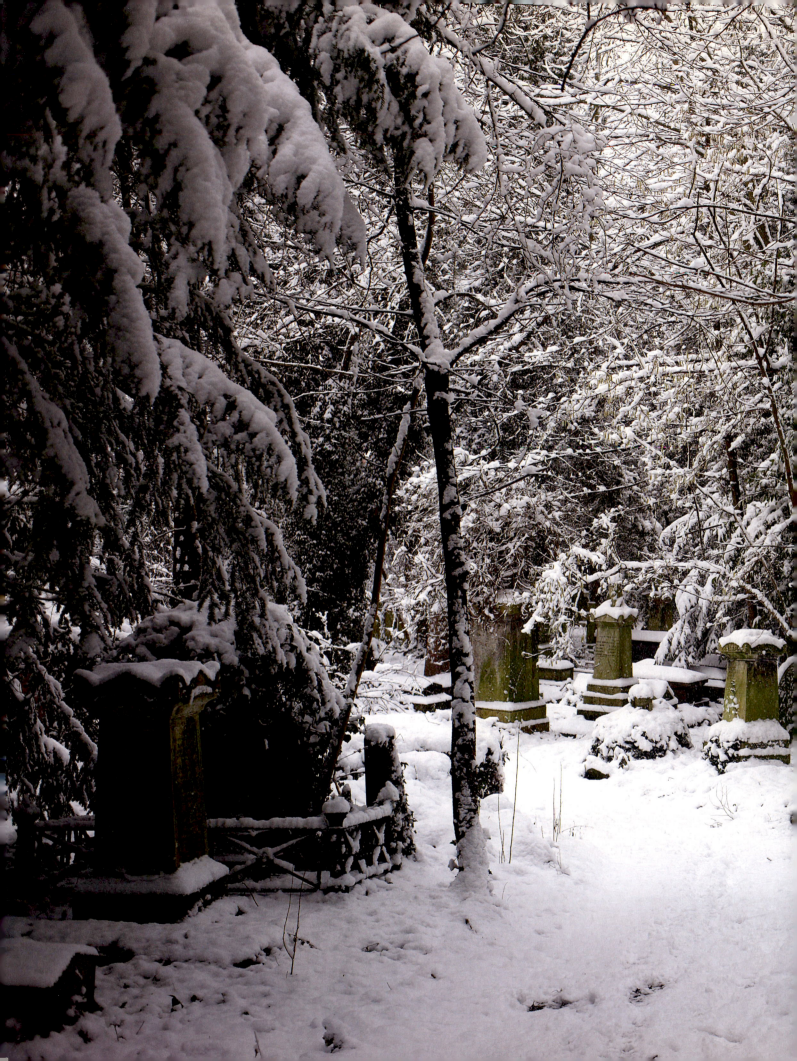

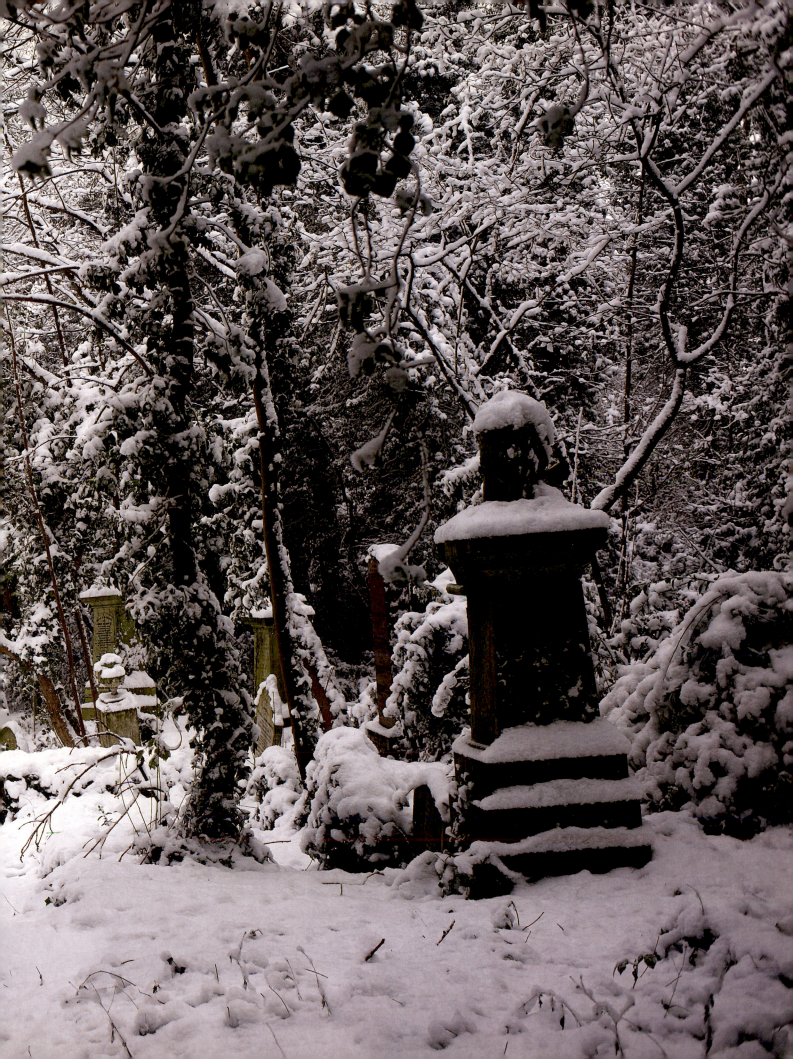

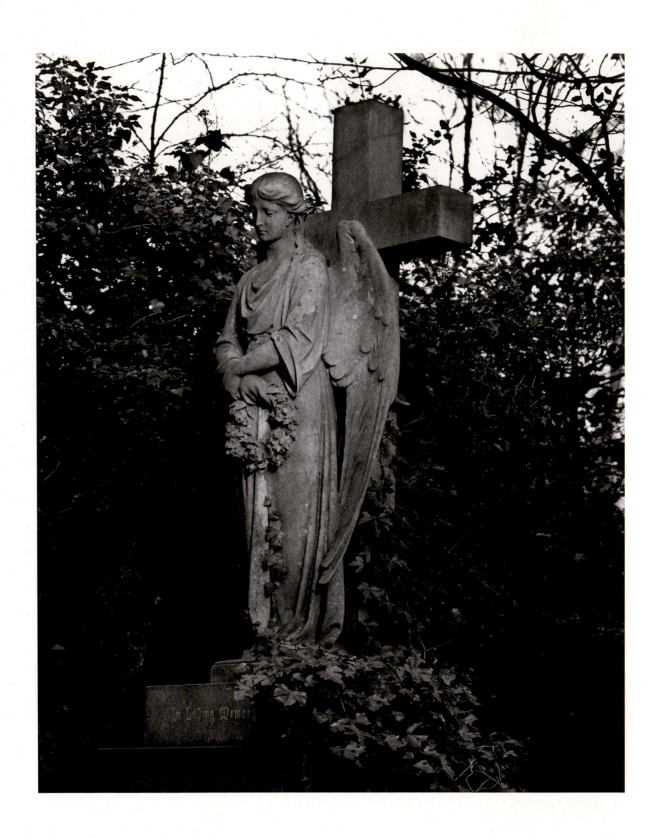

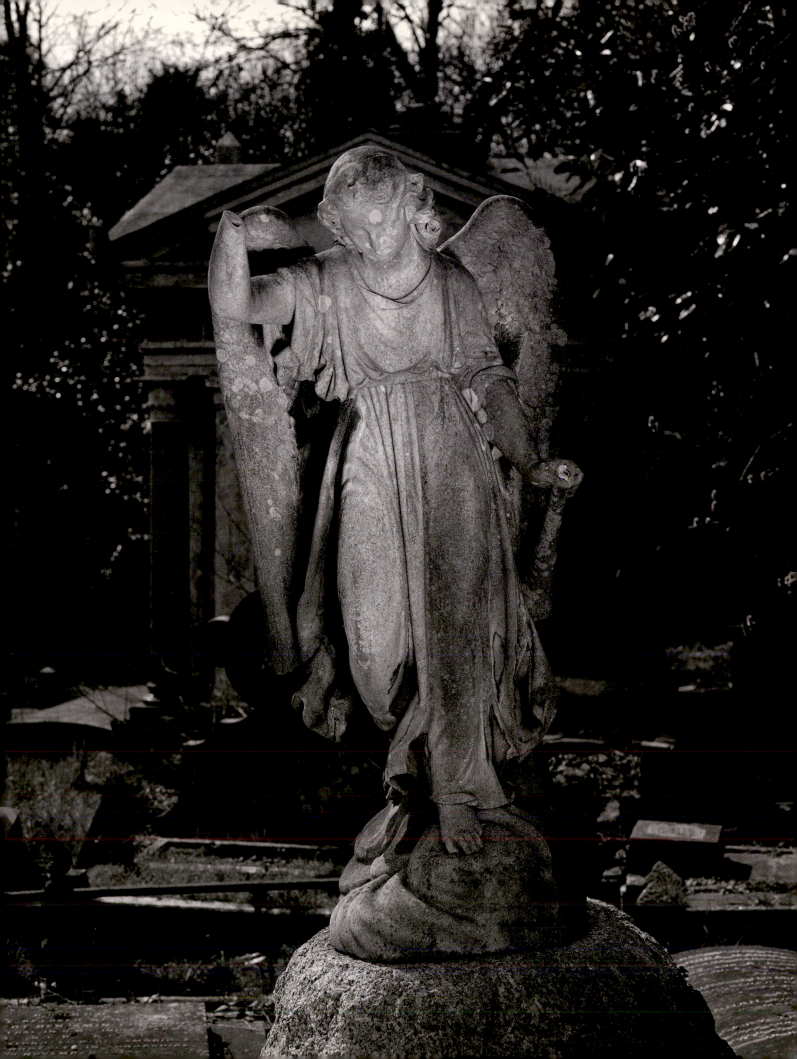

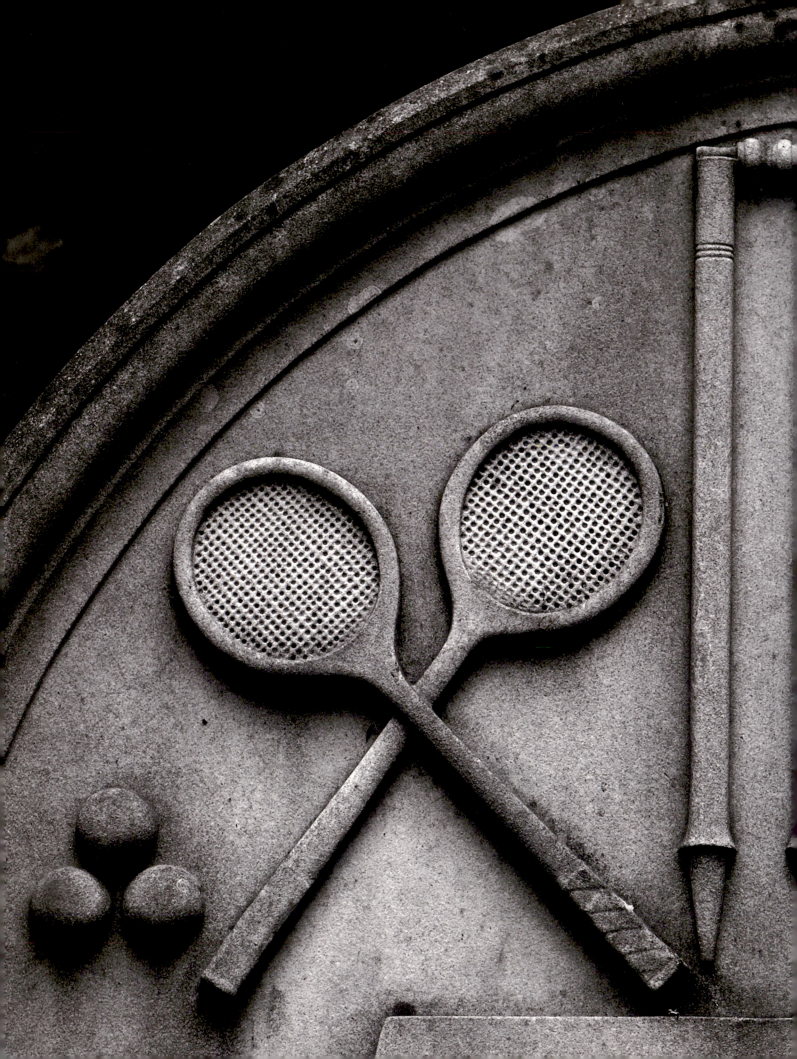

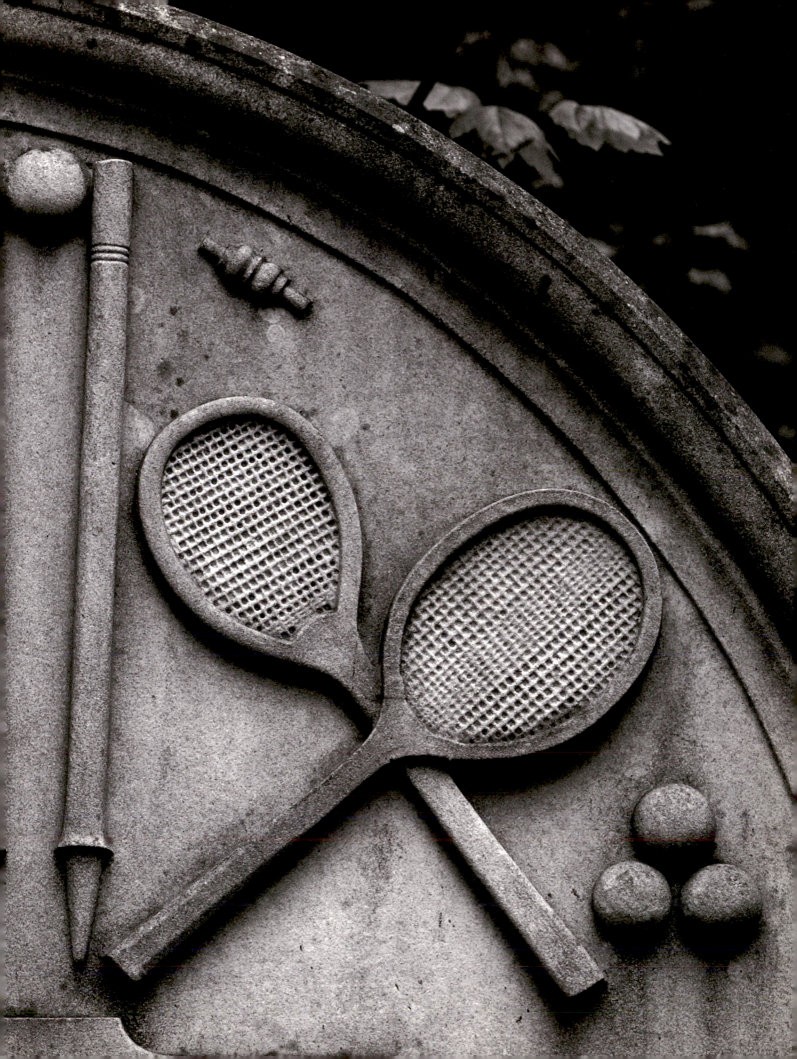

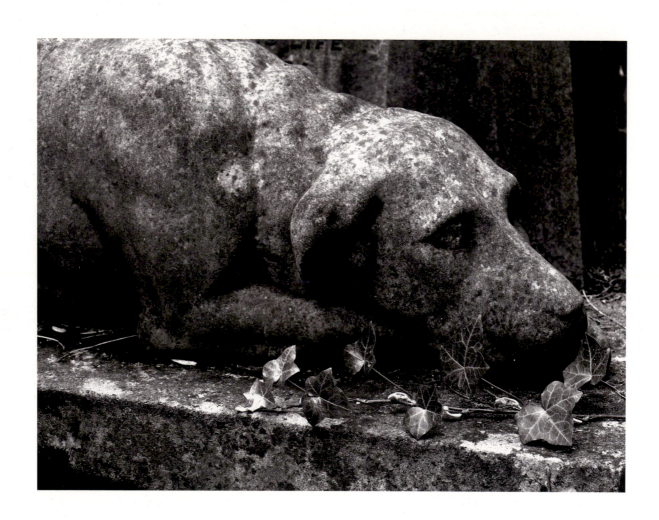

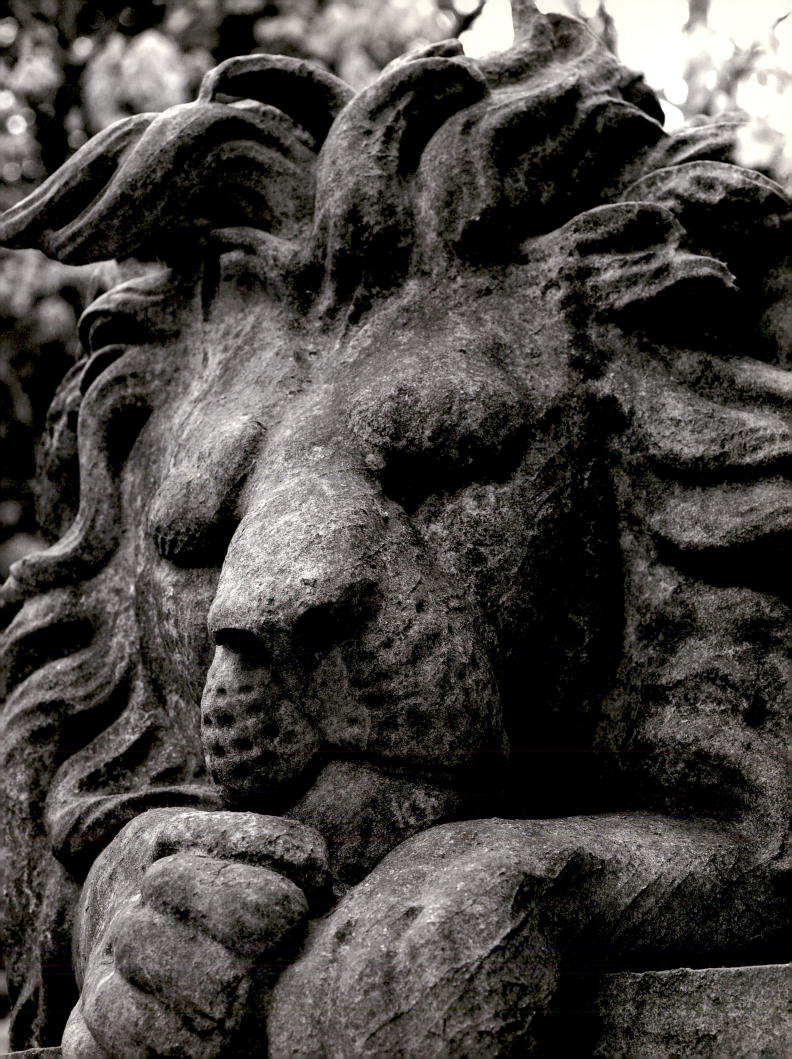

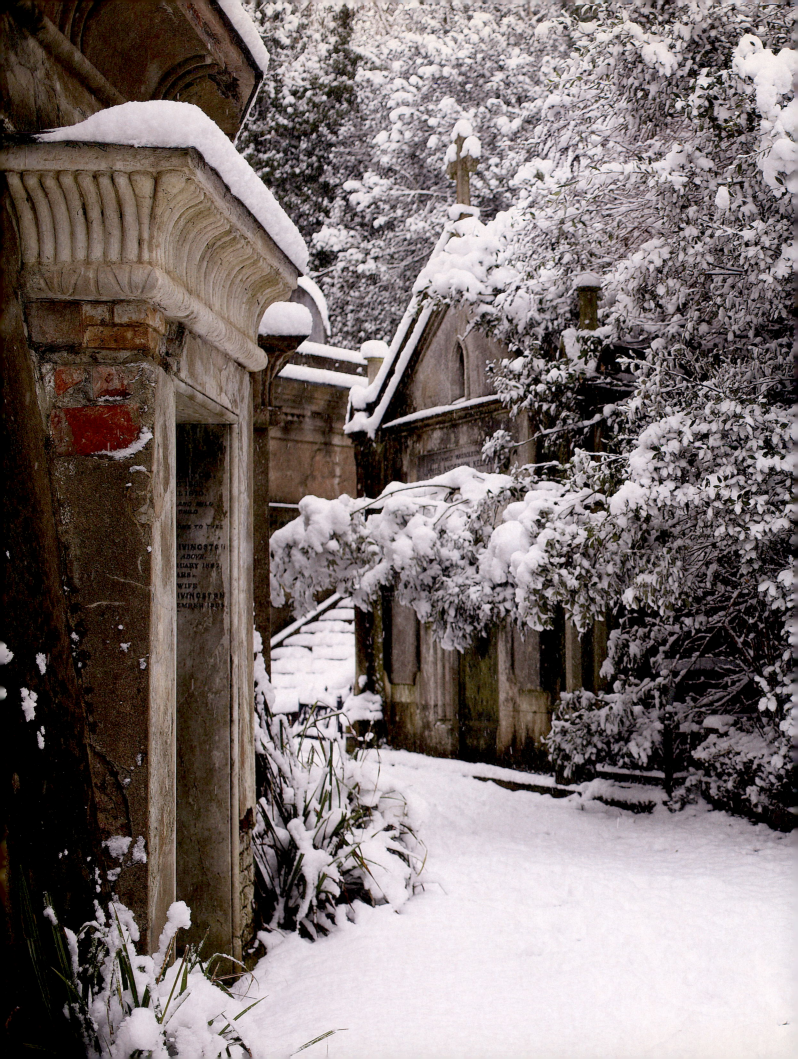

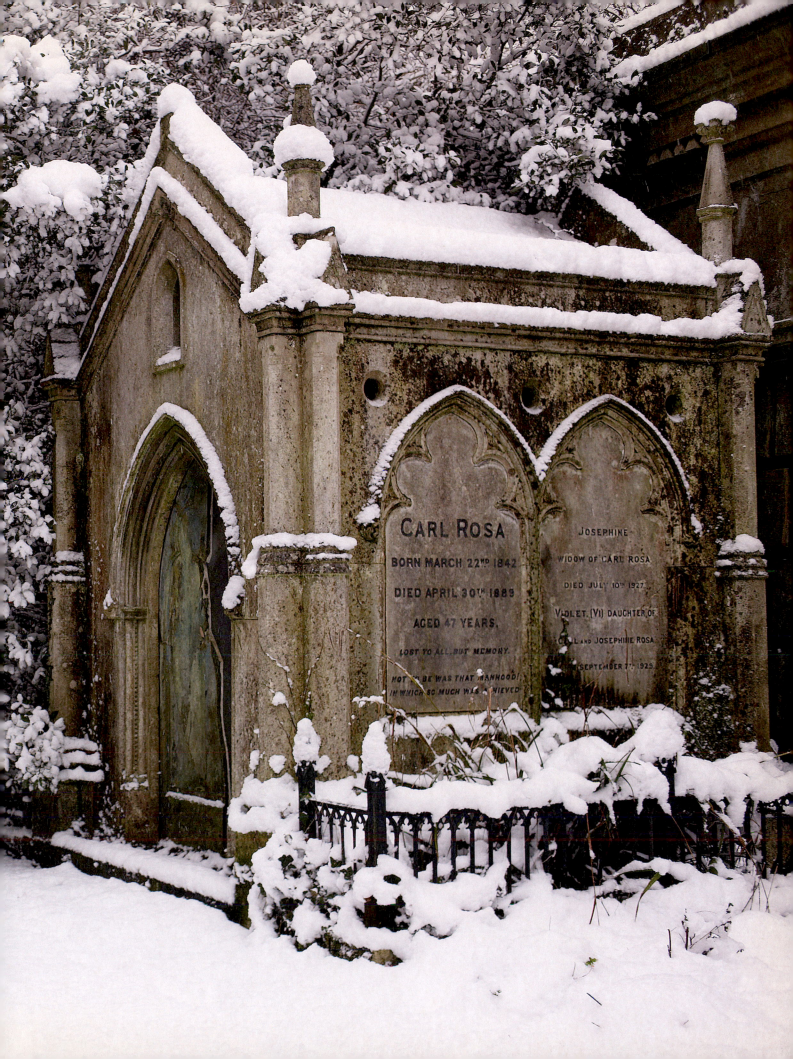

CARL ROSA

BORN MARCH 22ND 1842

DIED APRIL 30TH 1889

AGED 47 YEARS.

LOST TO ALL BUT MEMORY.

NOT AS BE WAS THAT MANHOOD/
IN WHICH SO MUCH WAS ACHIEVED

JOSEPHINE

WIDOW OF CARL ROSA

DIED JULY 10TH 1927

VIOLET (VI) DAUGHTER OF

CARL AND JOSEPHINE ROSA

SEPTEMBER 7TH 1929

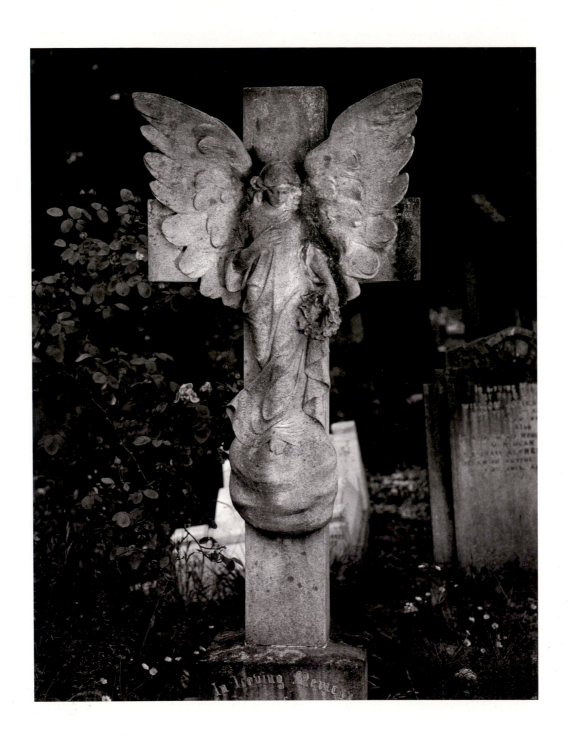

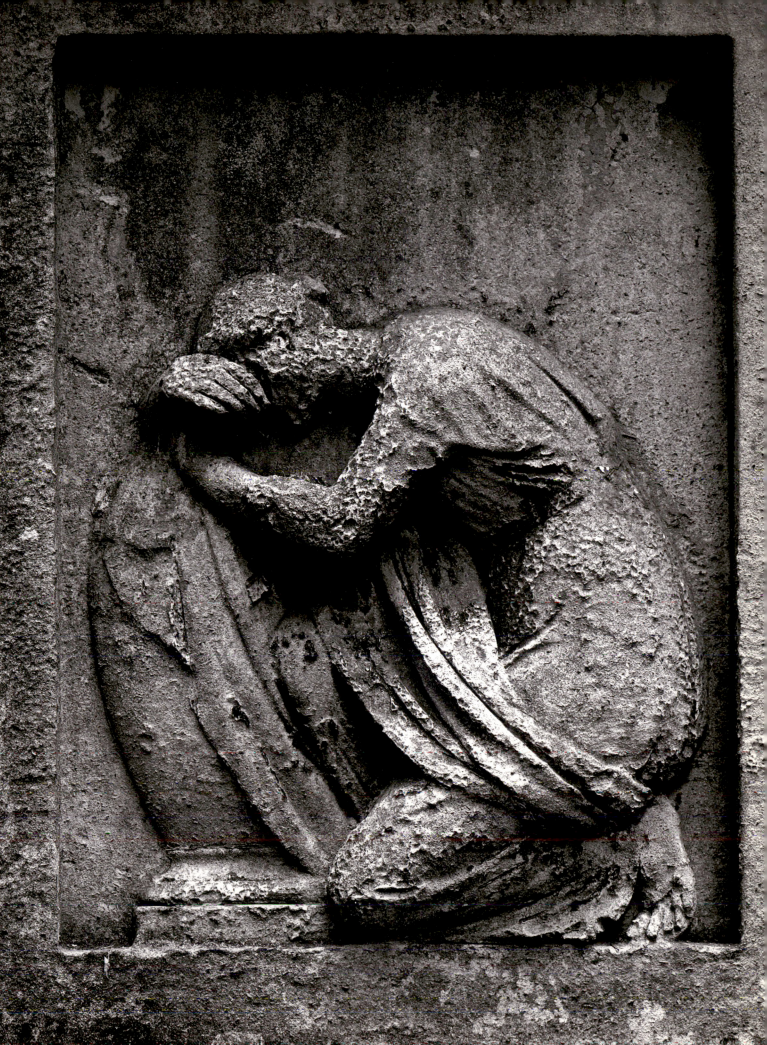

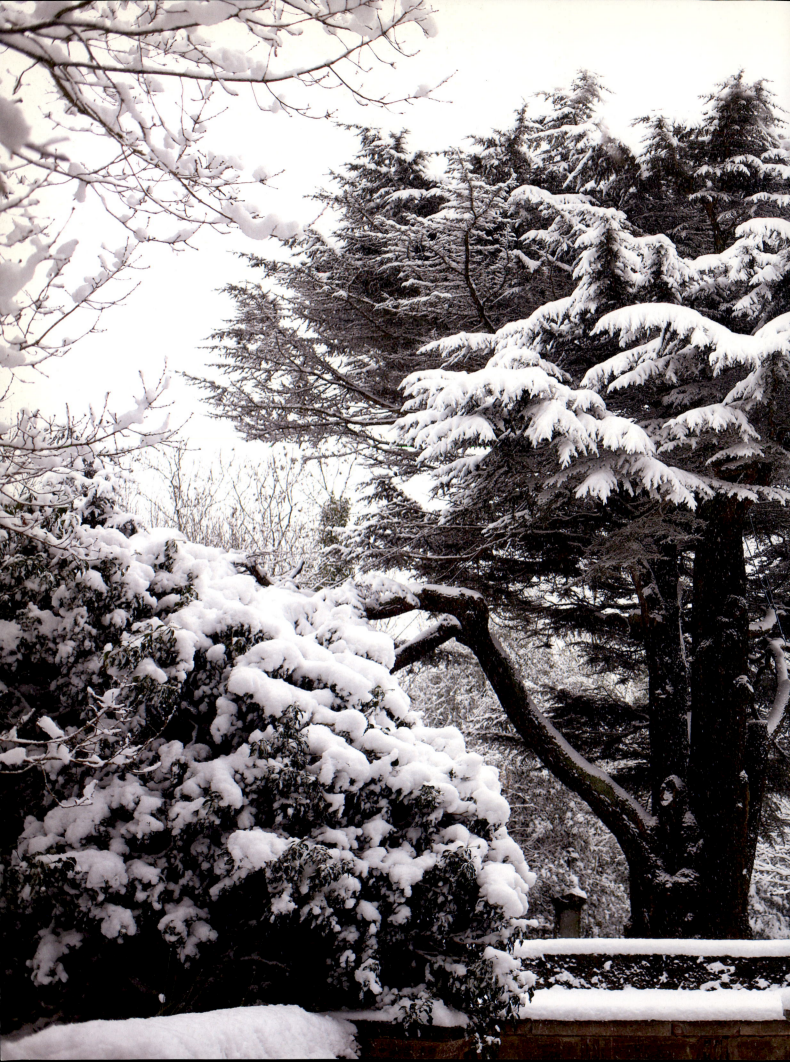

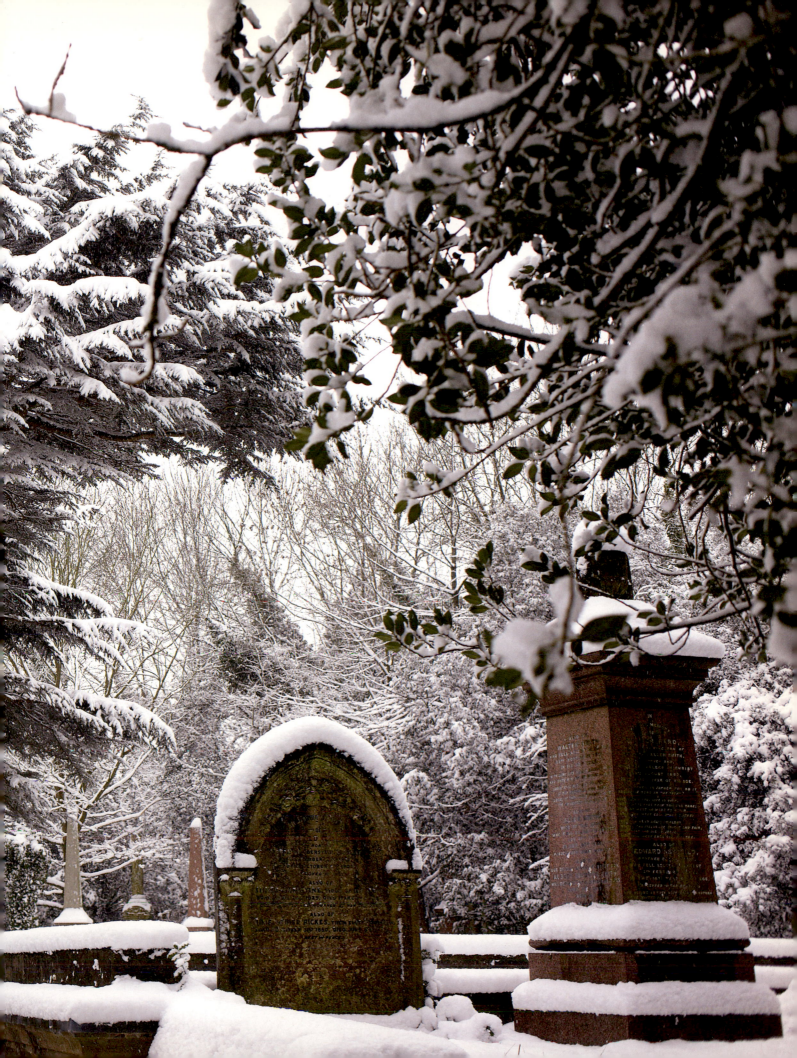

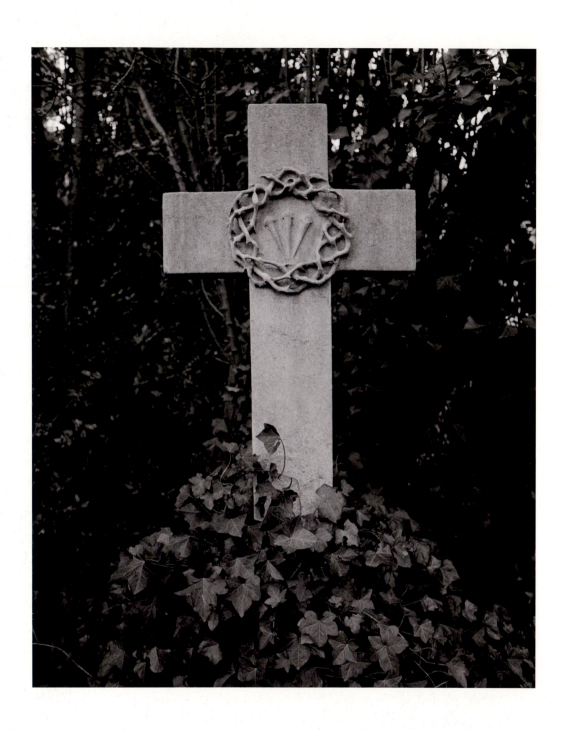

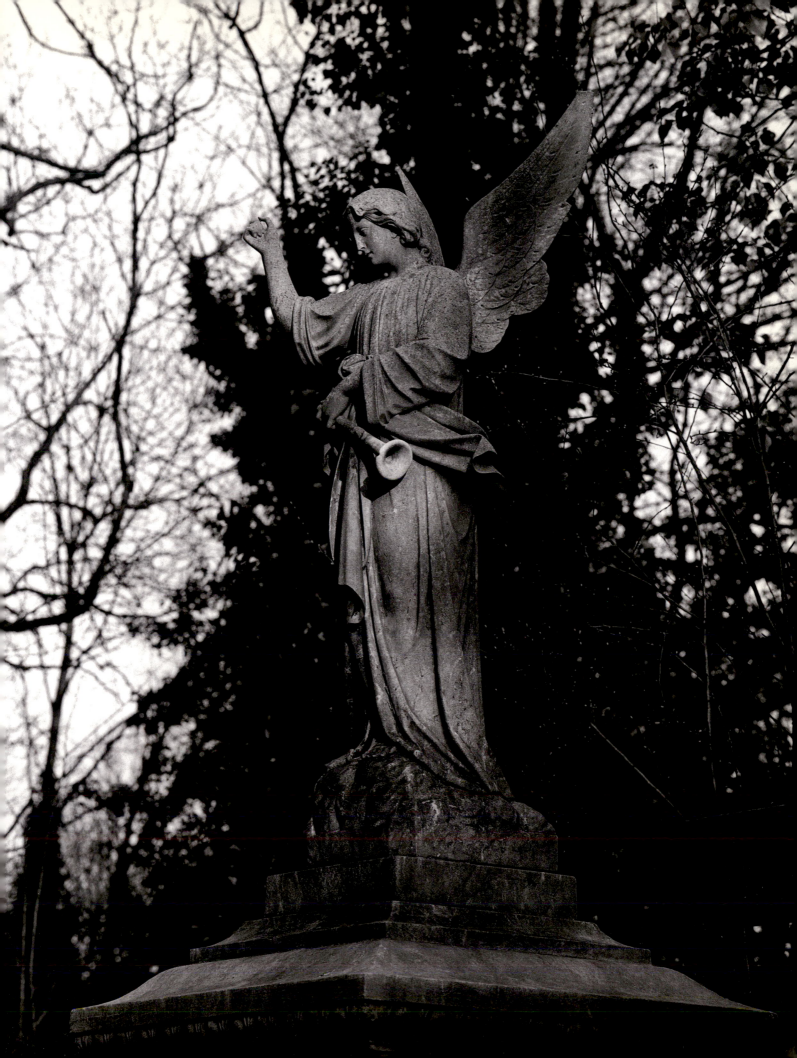

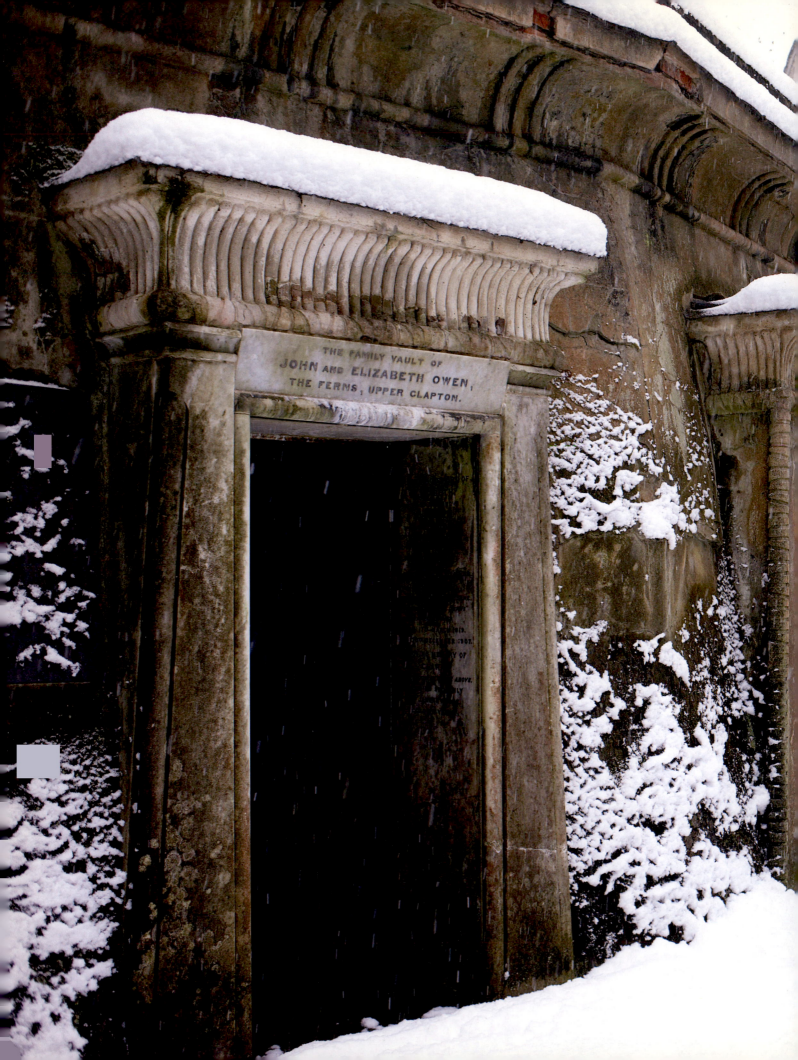

THE FAMILY VAULT OF
JOHN AND ELIZABETH OWEN,
THE FERNS, UPPER CLAPTON.

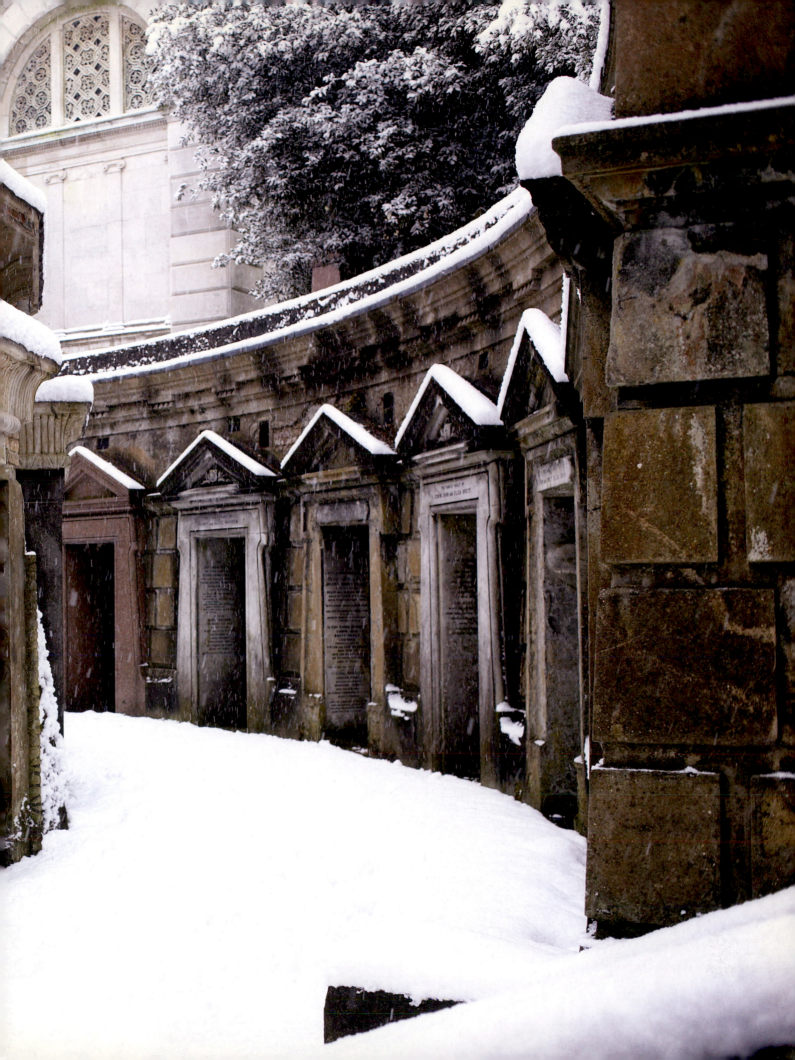

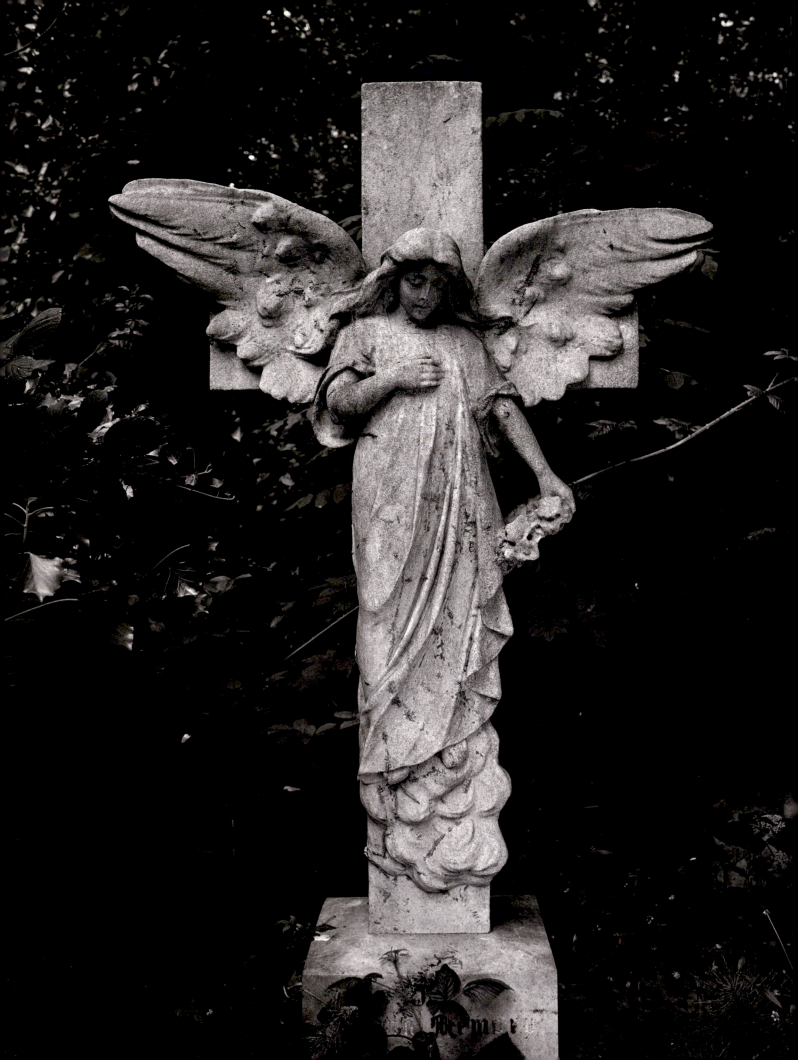

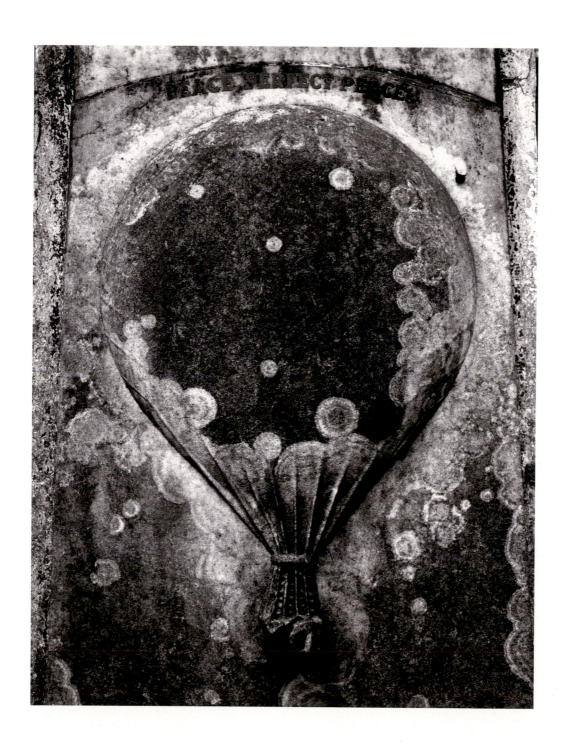

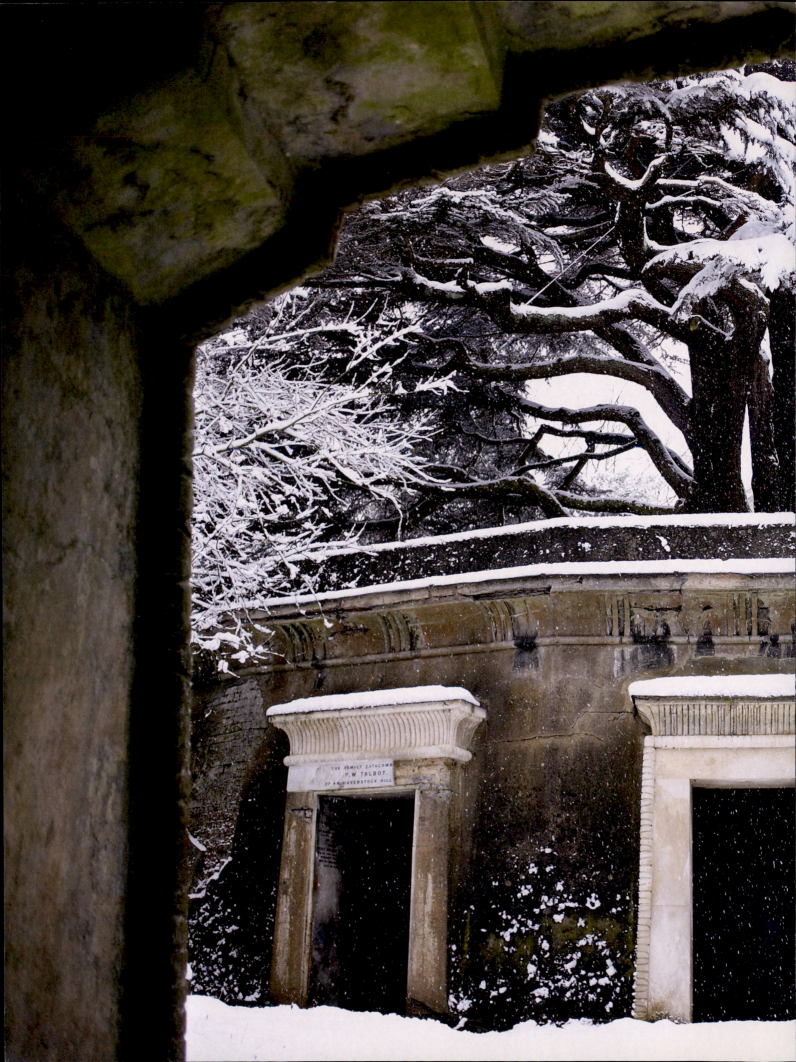

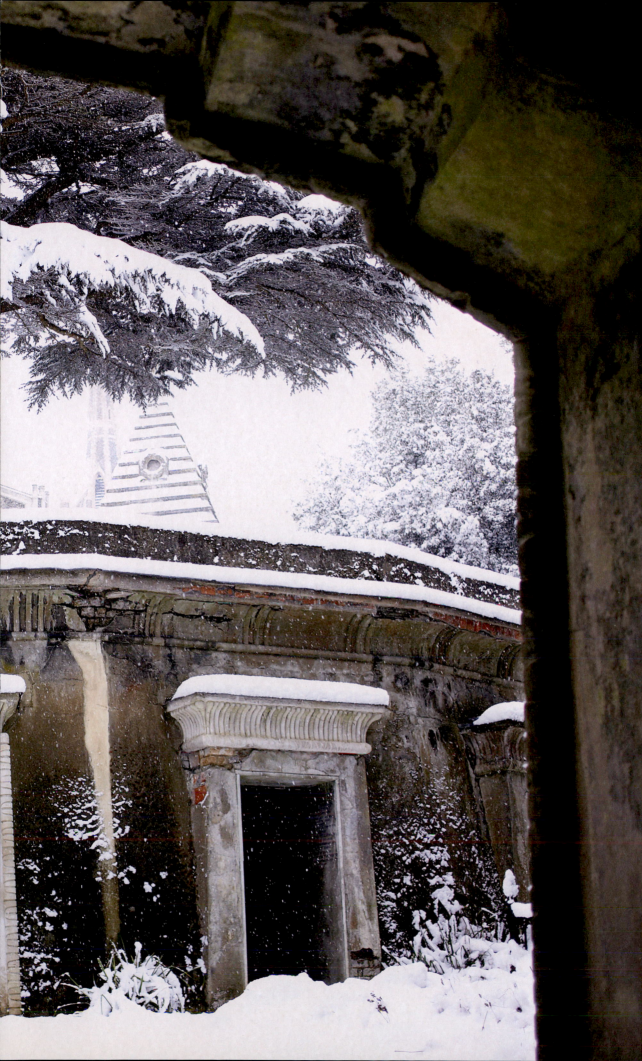

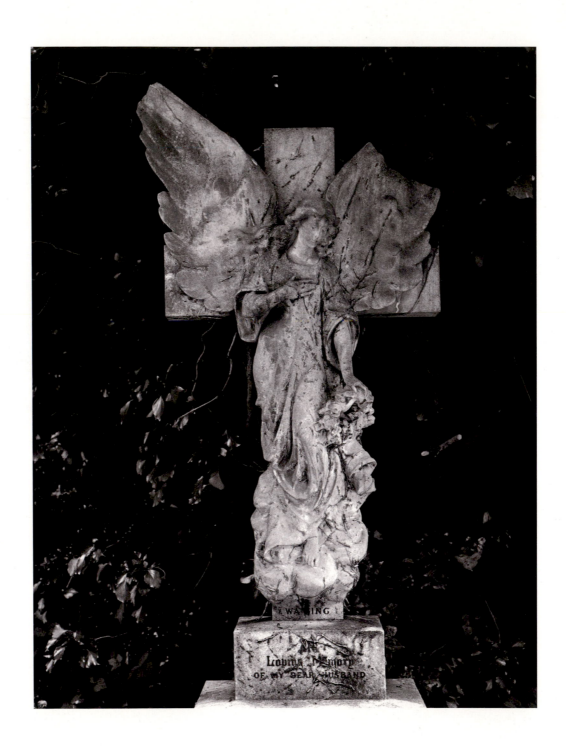

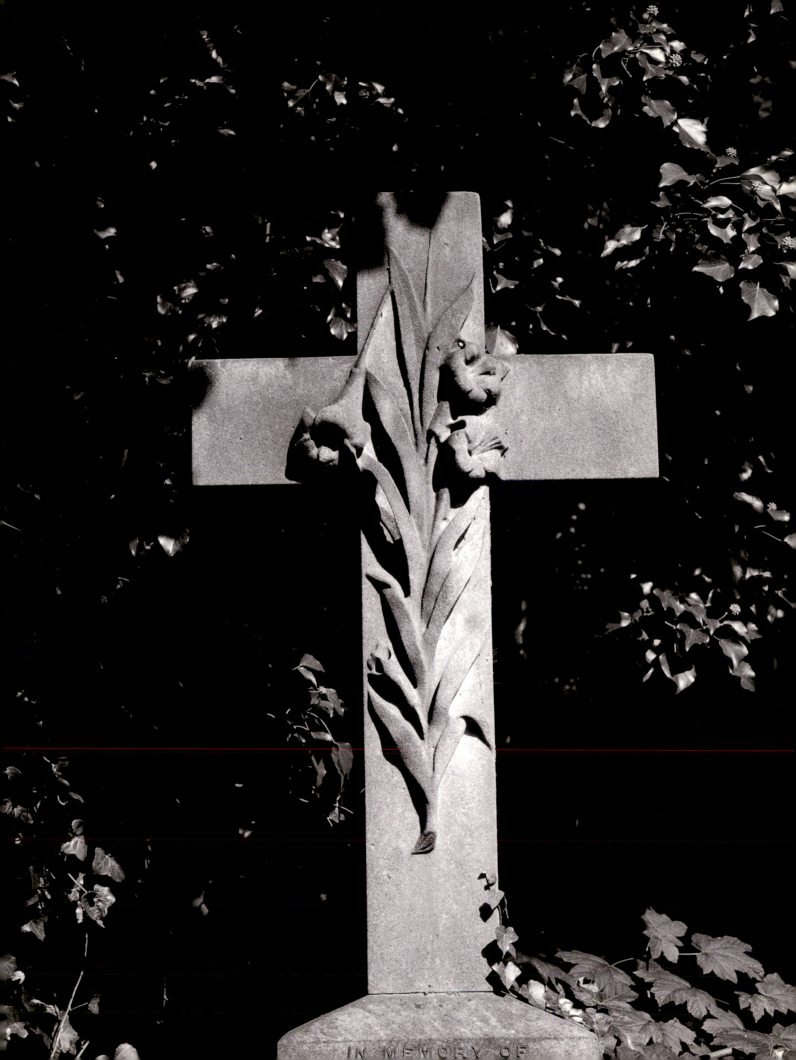

IN MEMORY OF

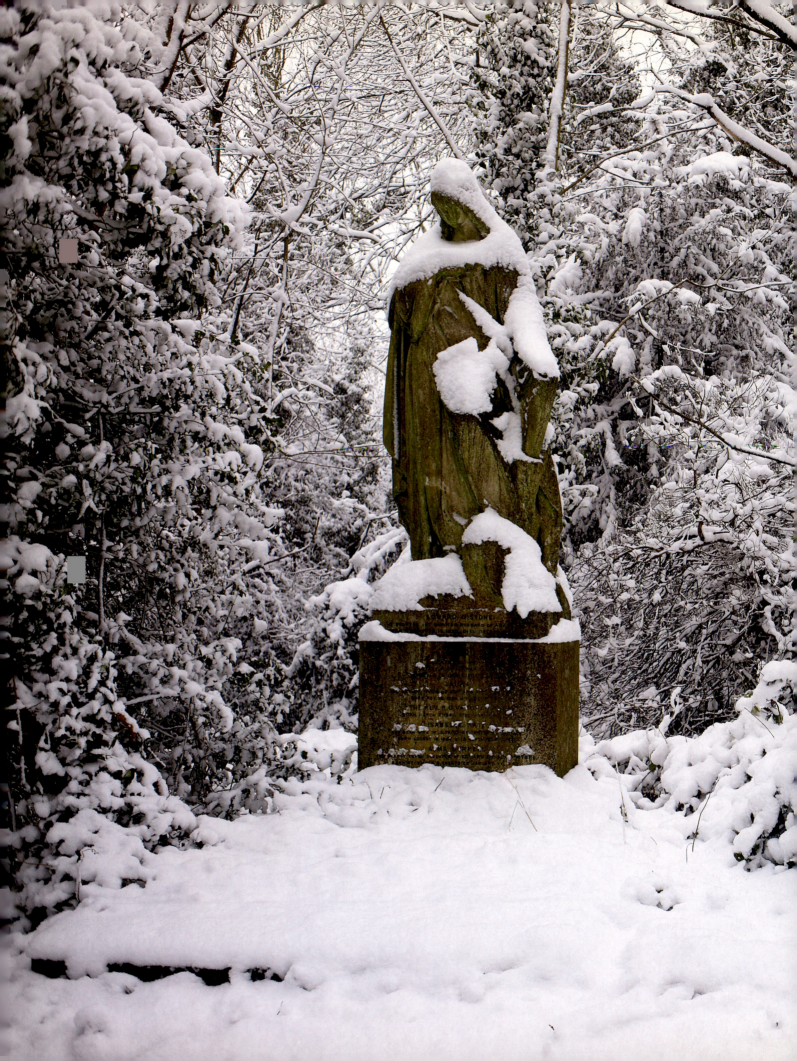

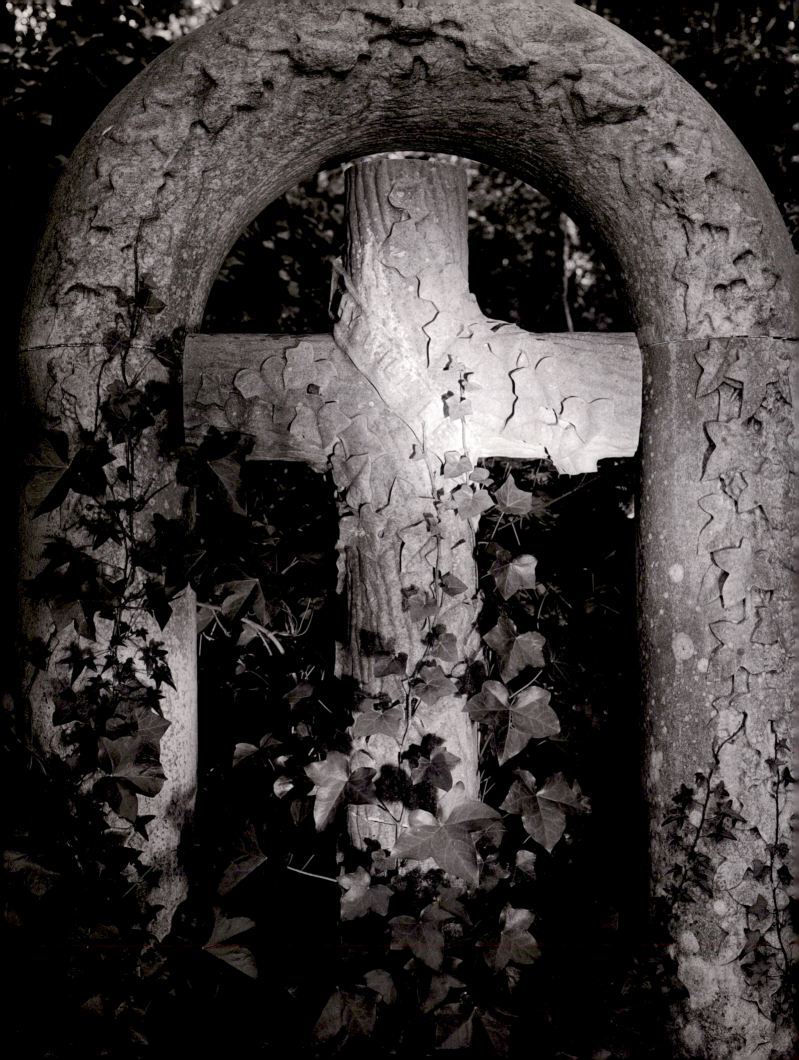

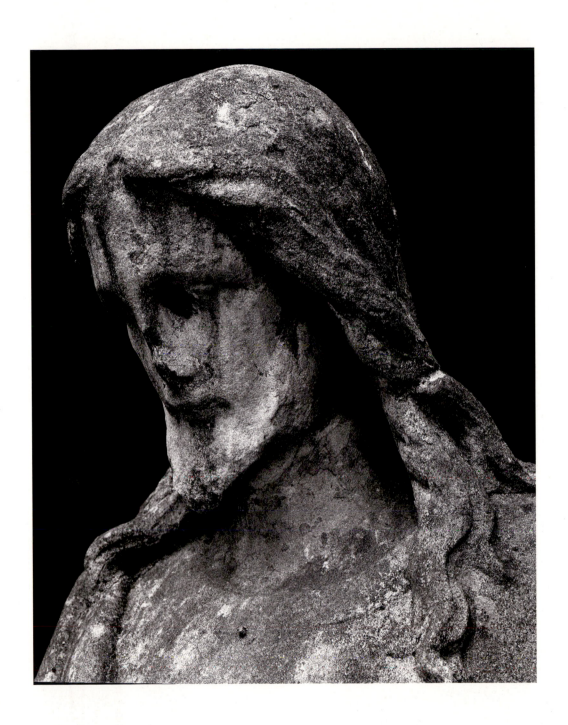

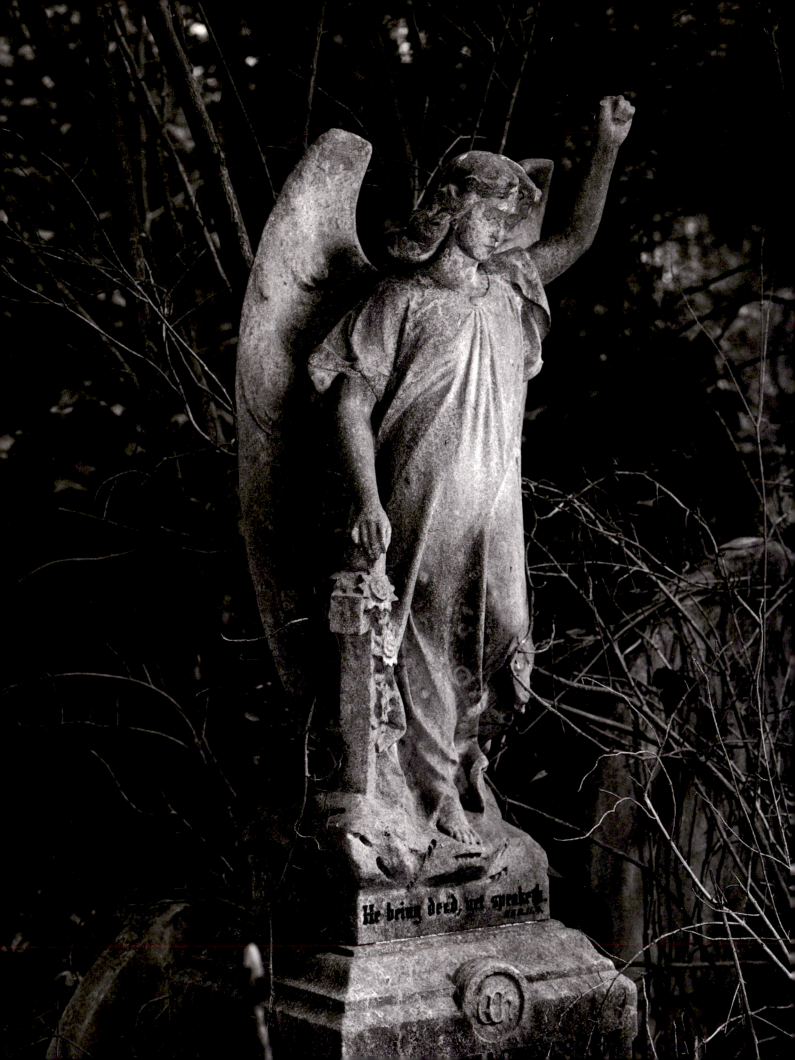

He being dead, yet speaketh. HEB. 11.4.

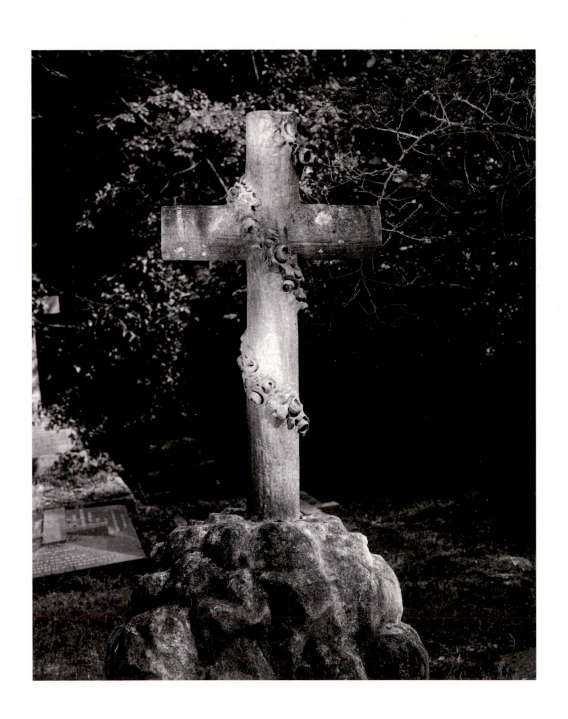

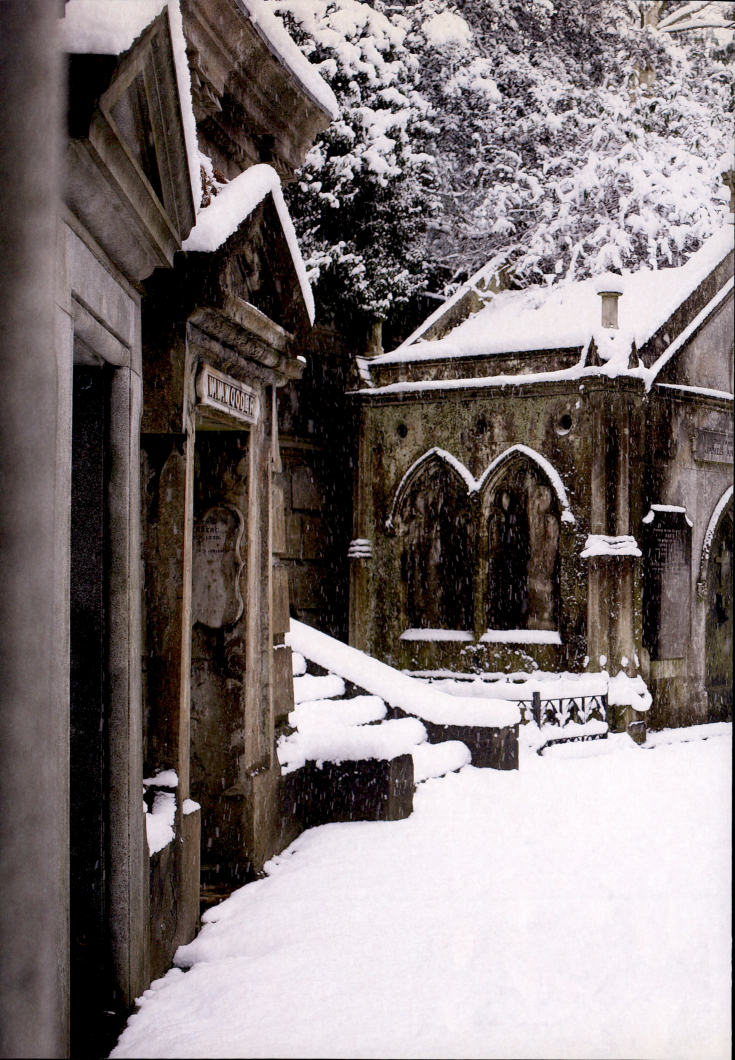

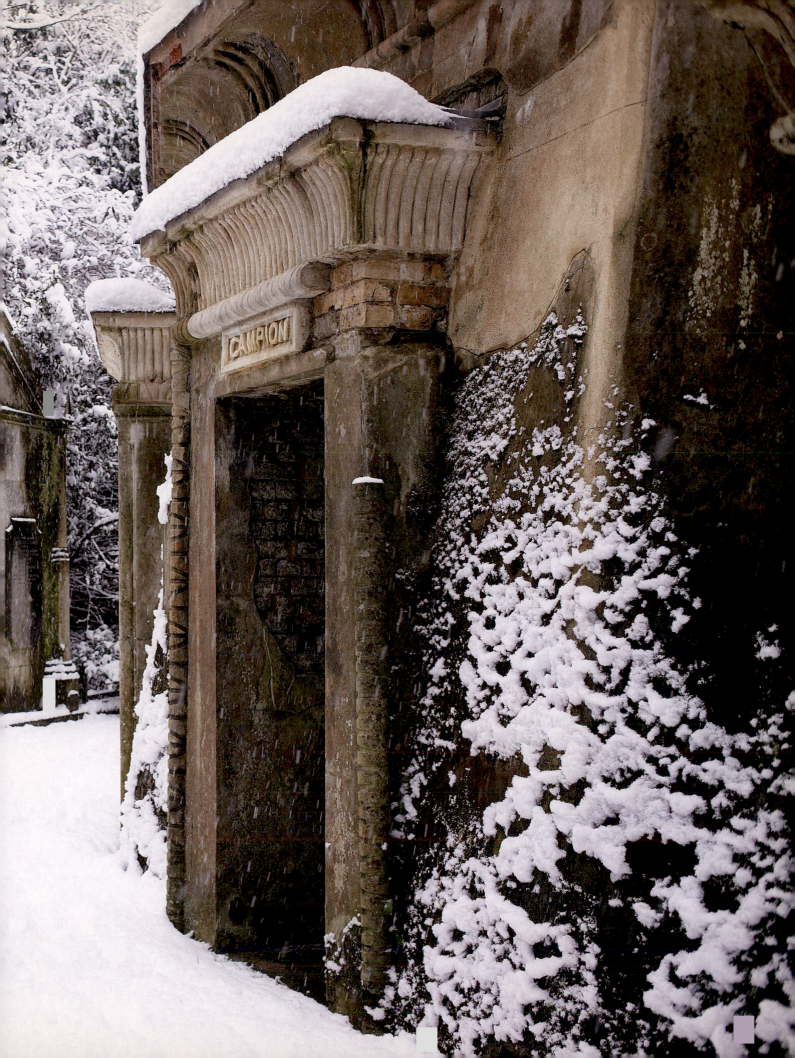

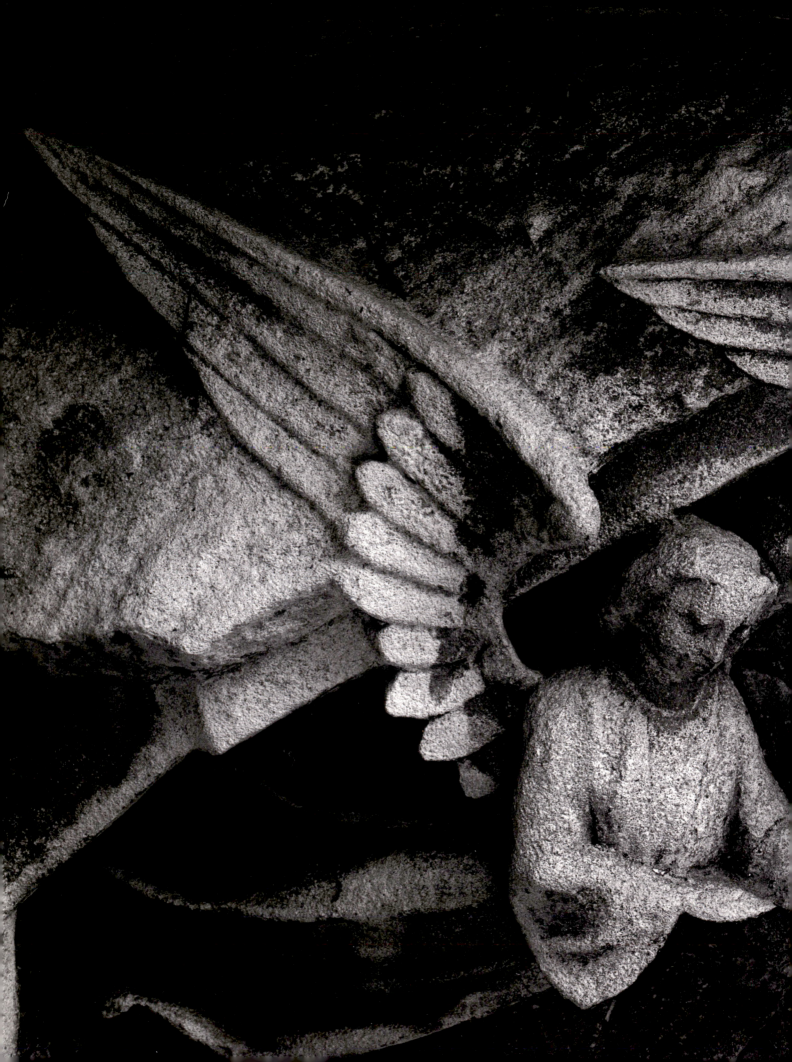

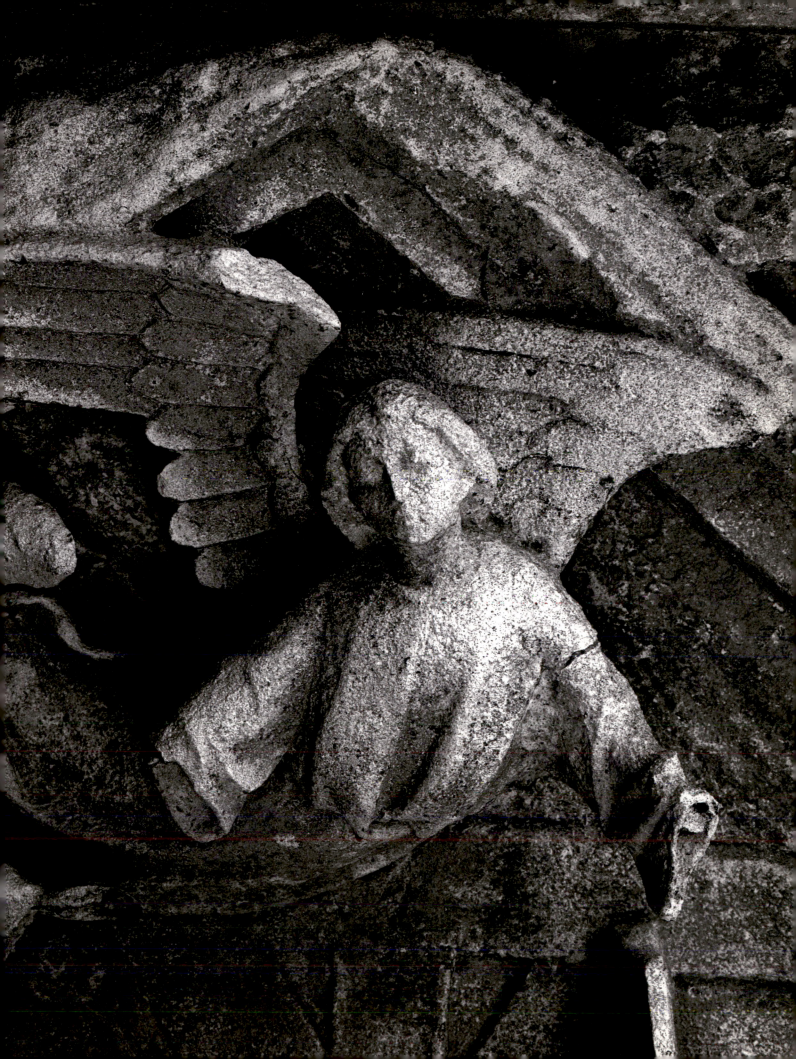

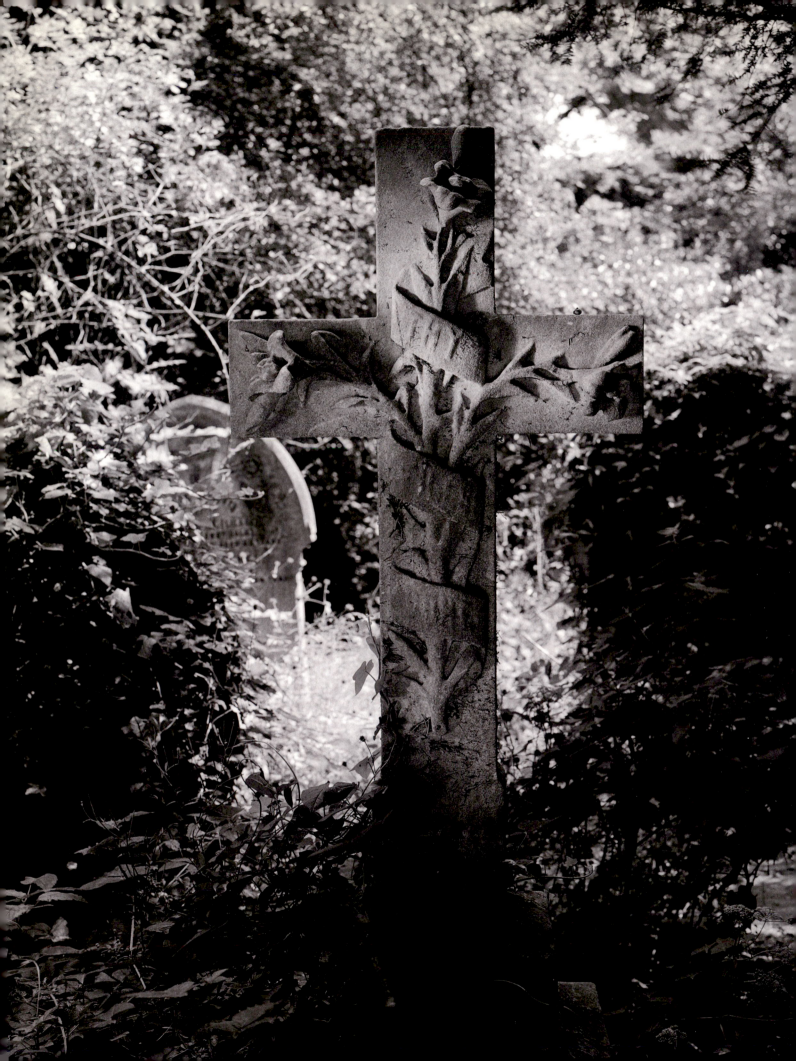

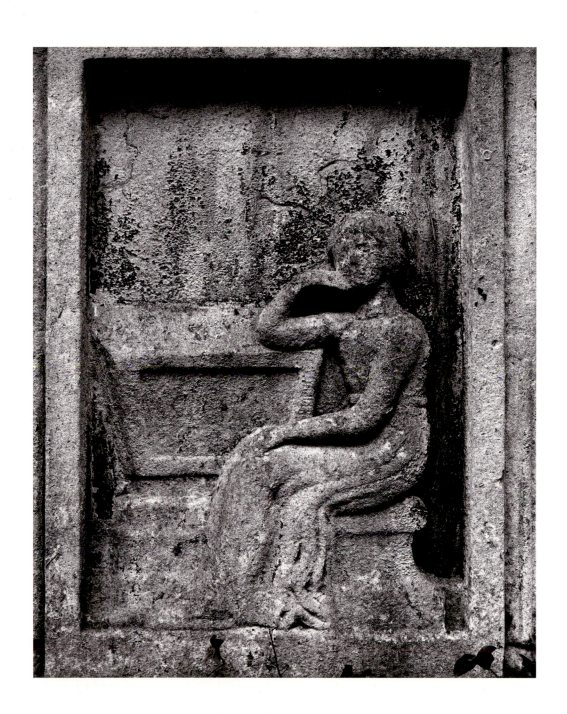

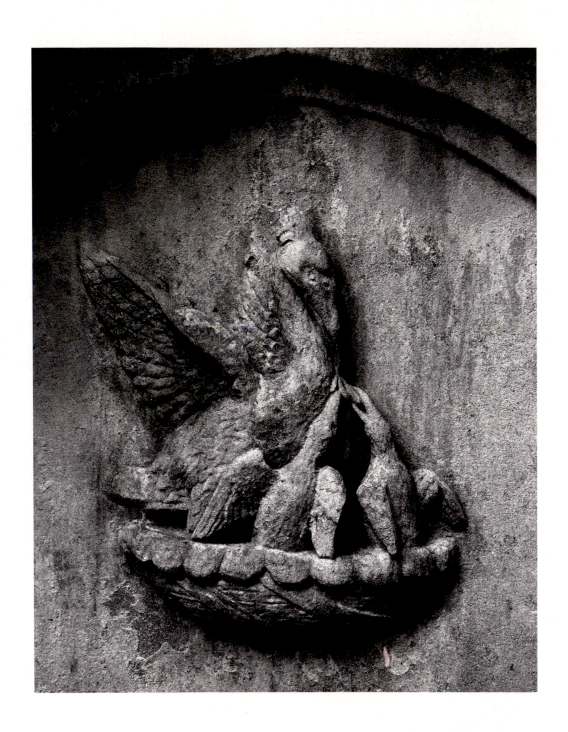

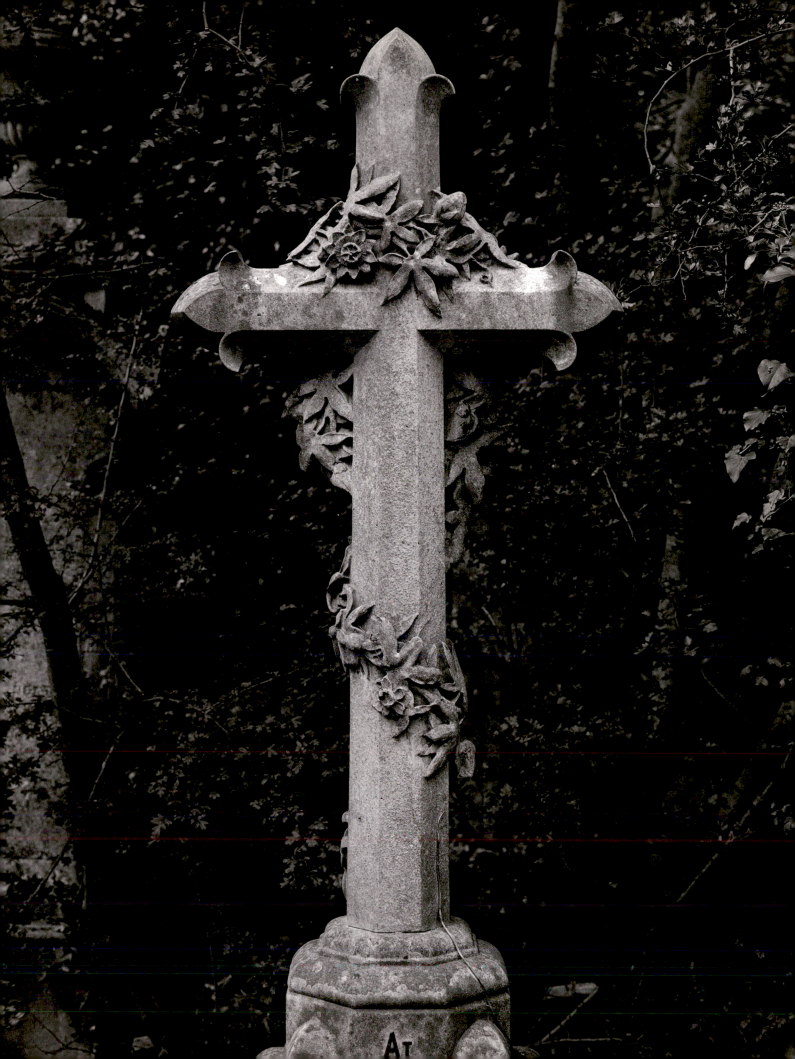

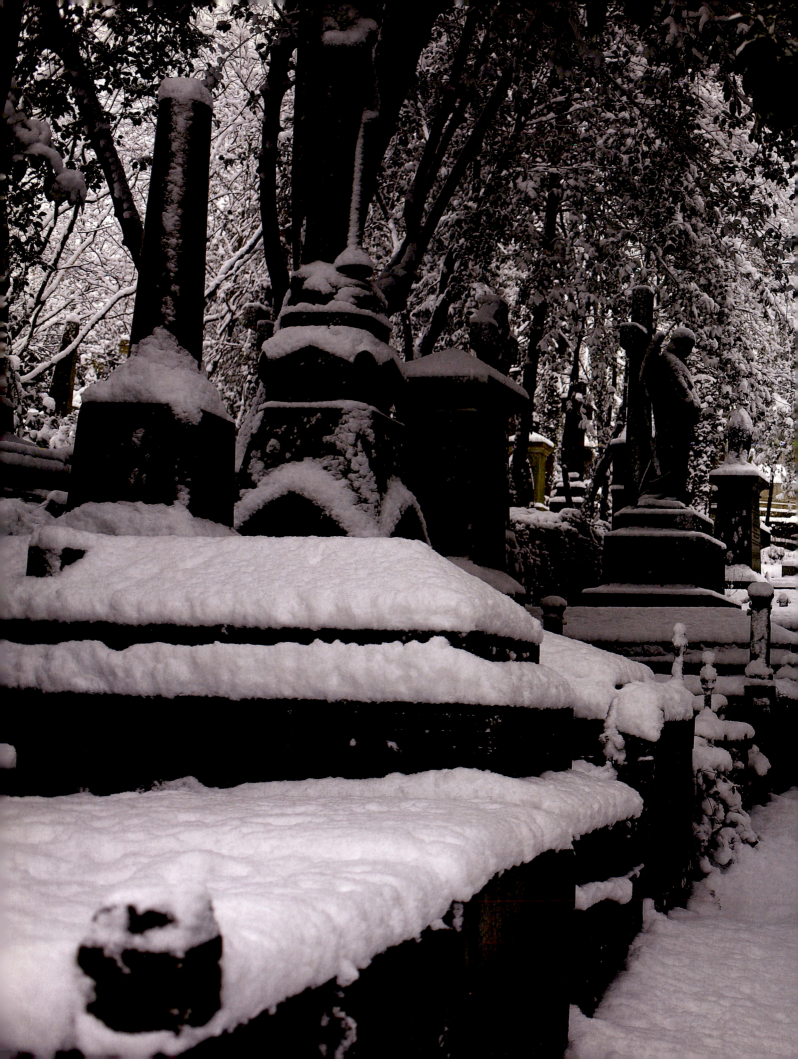

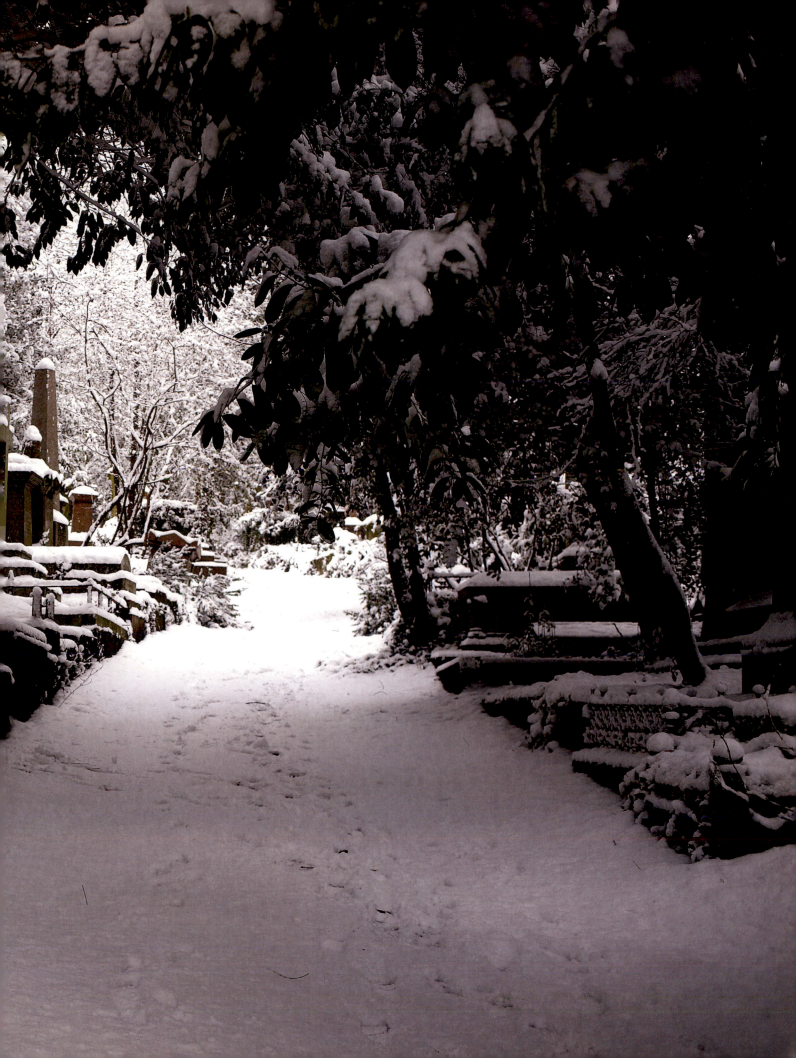

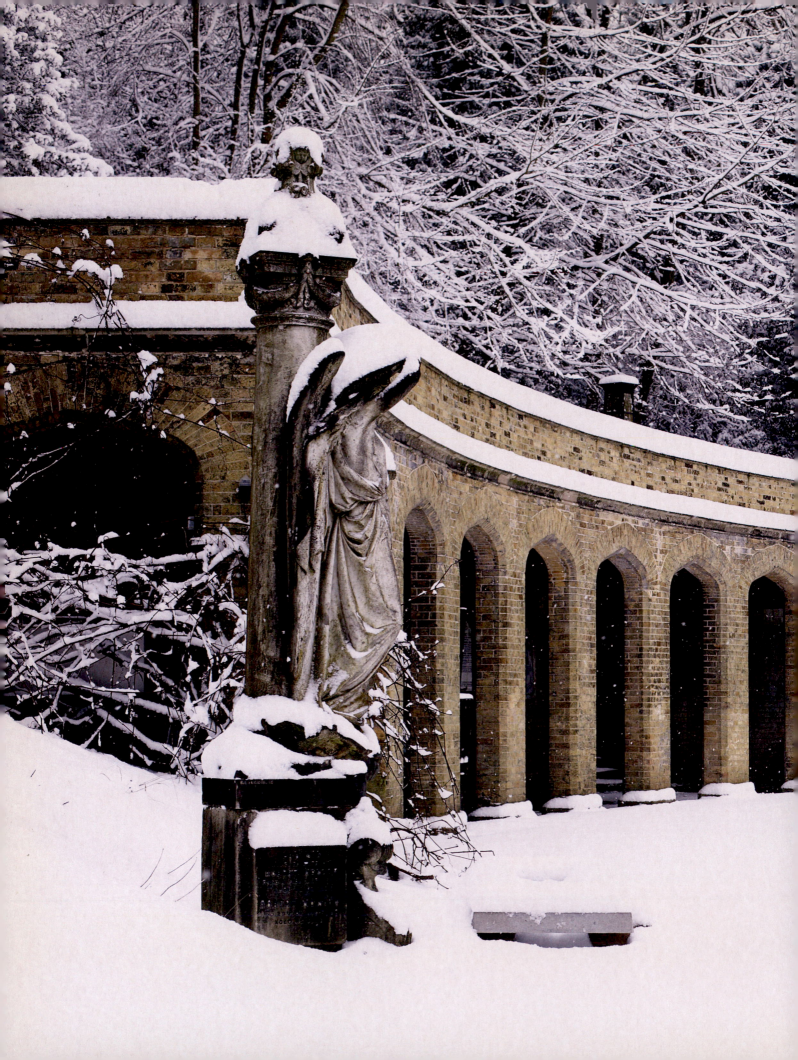

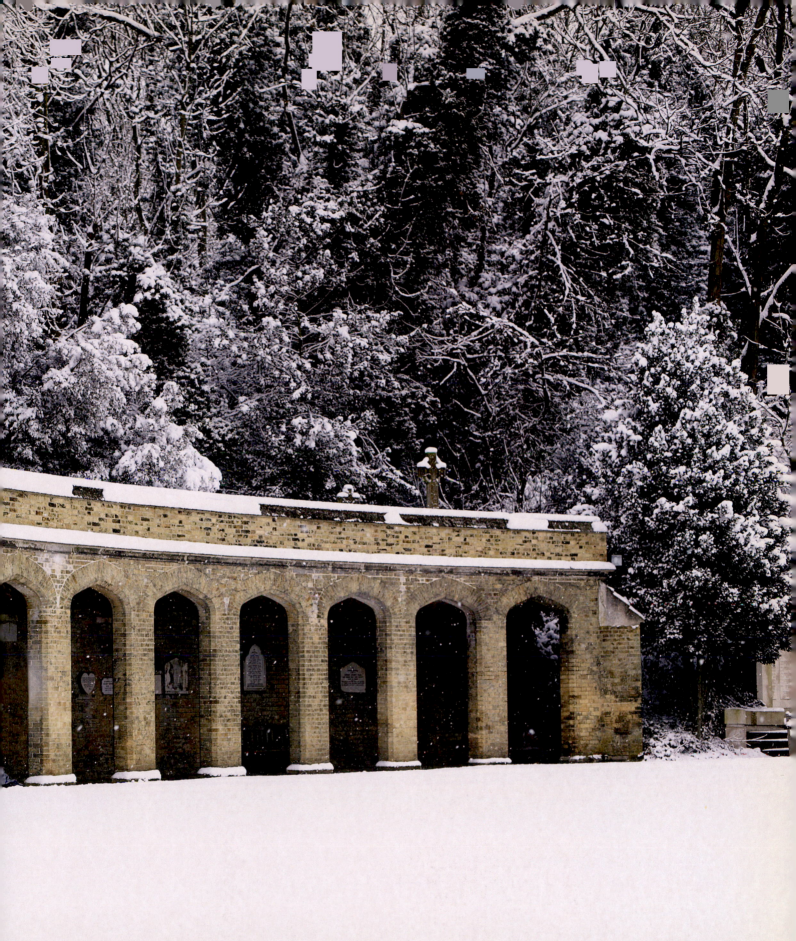

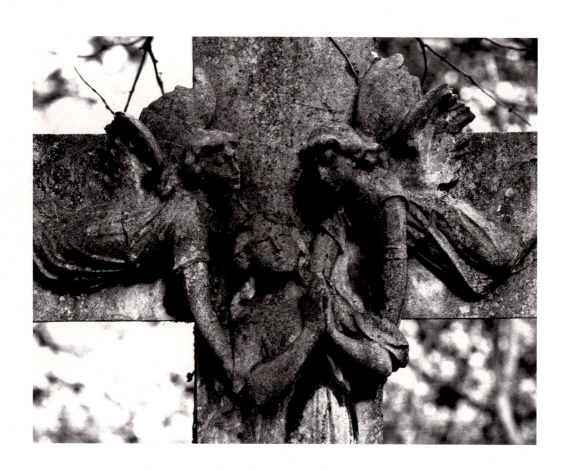

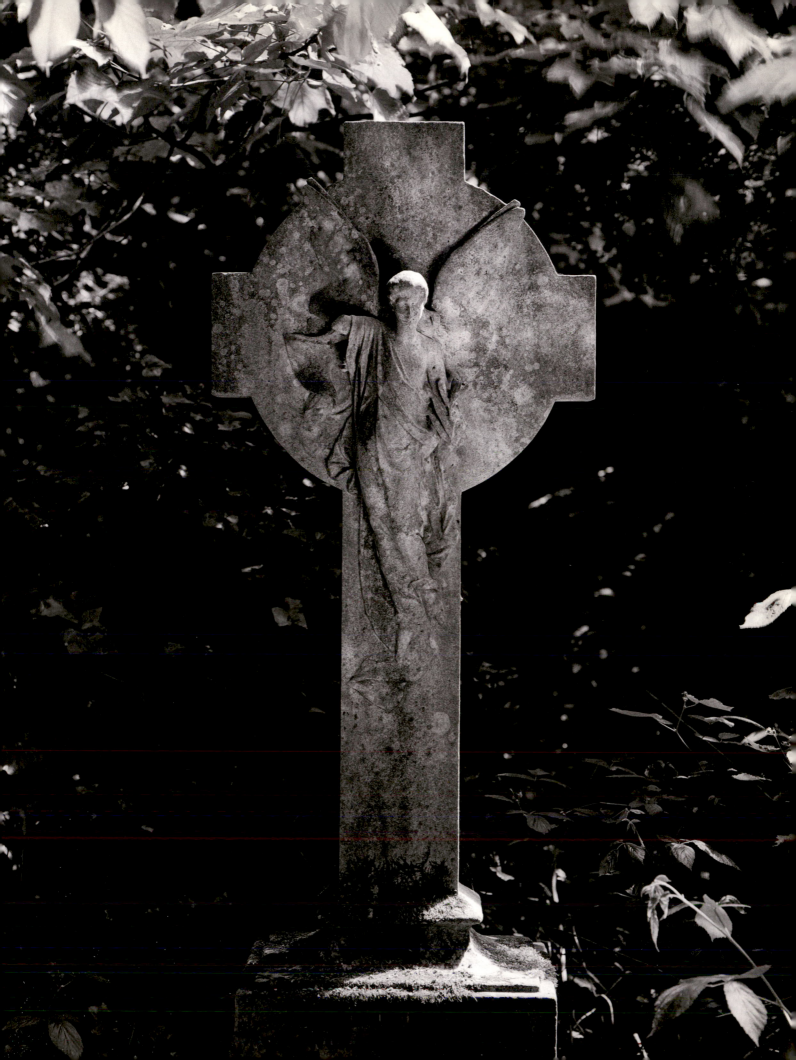

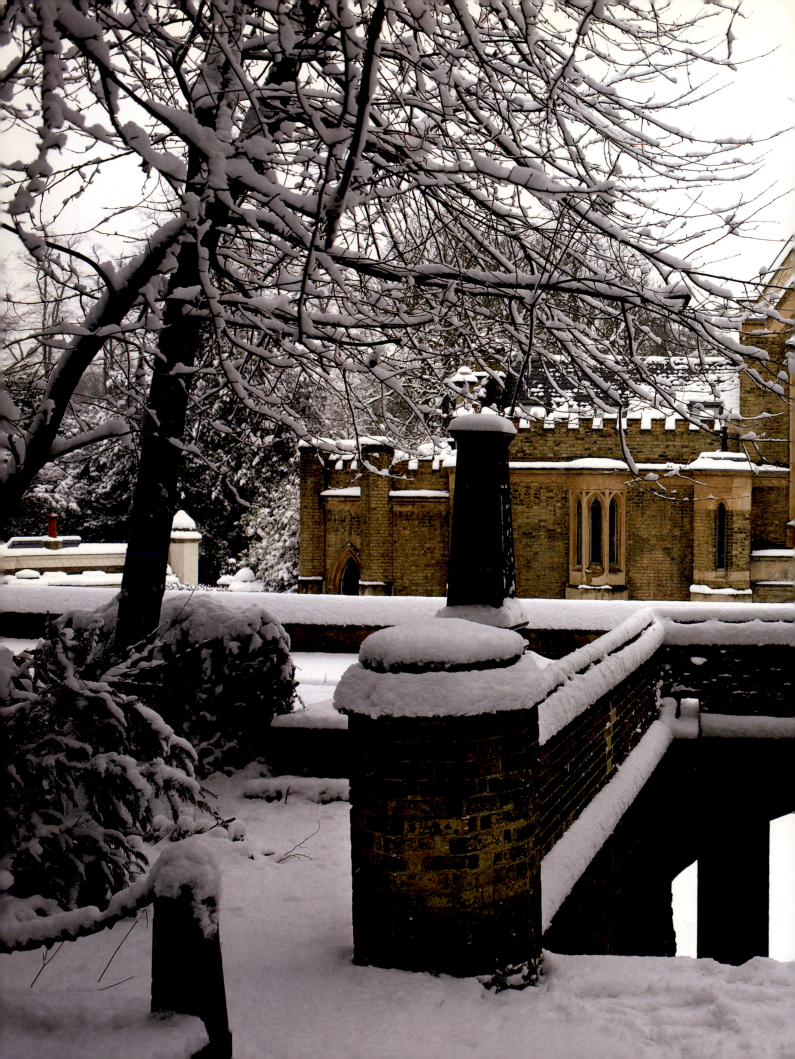

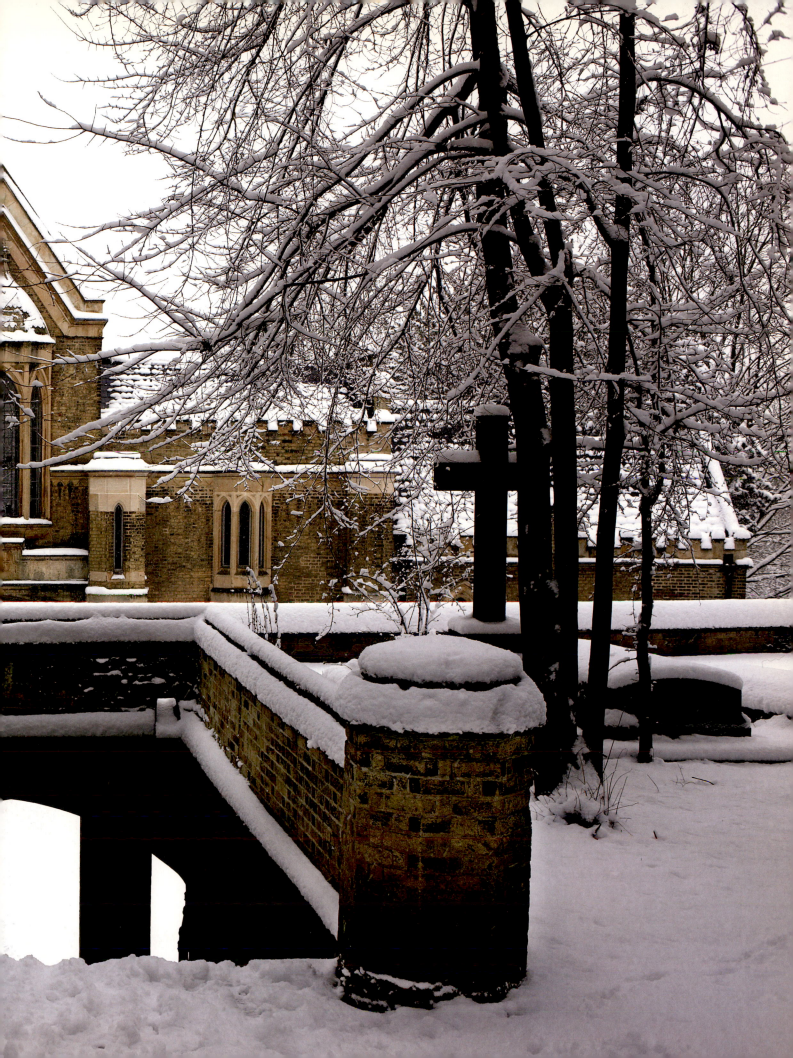

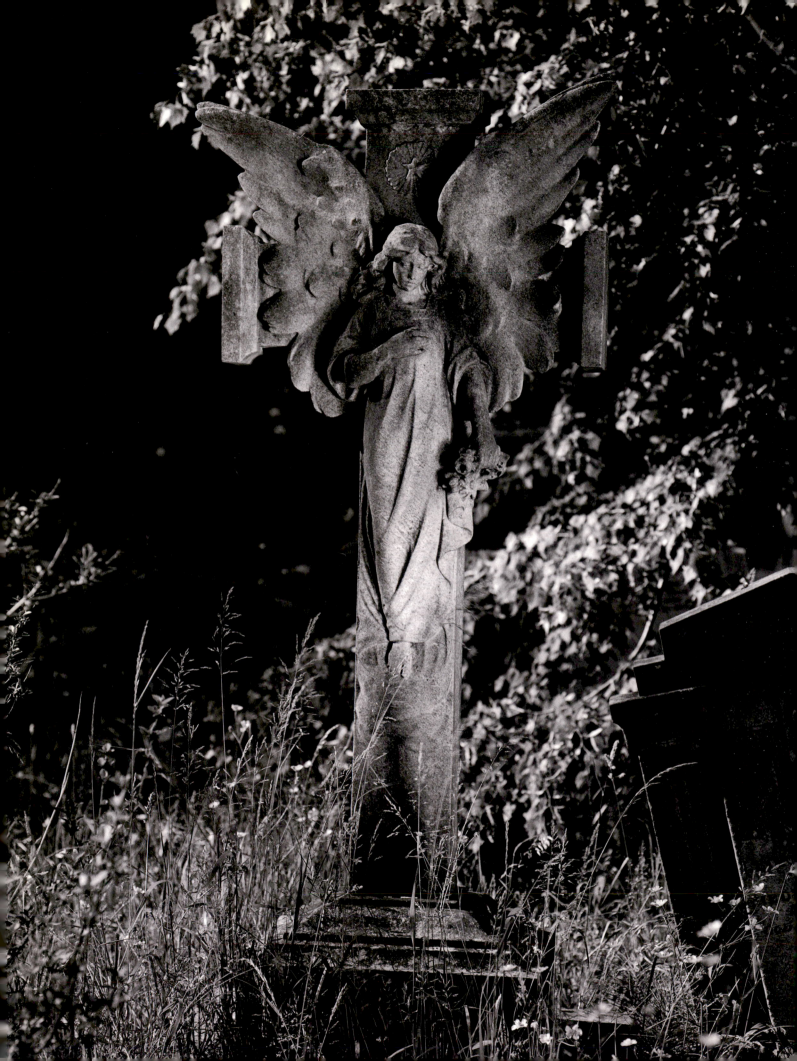

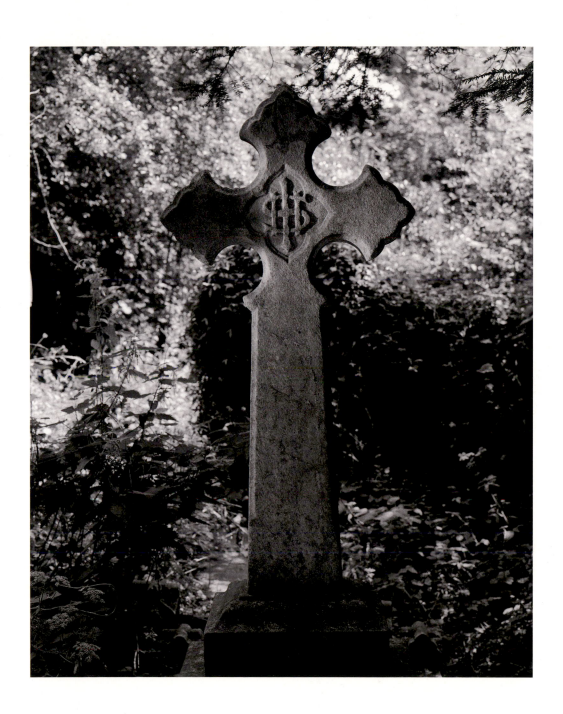

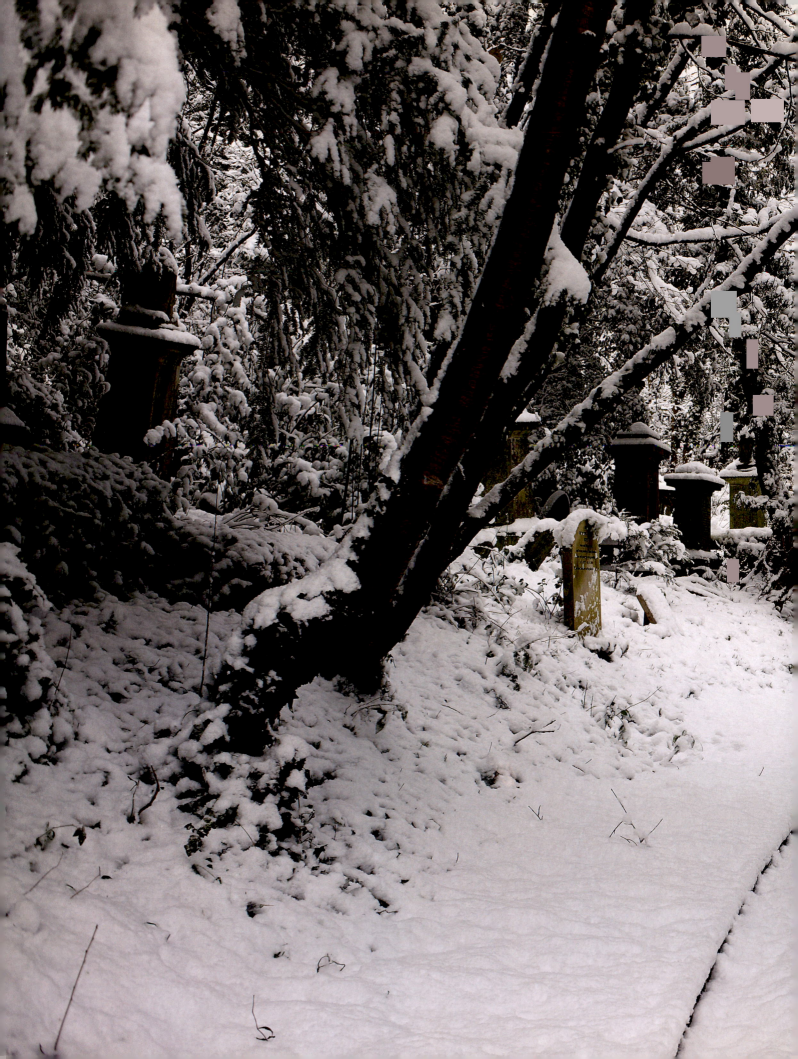

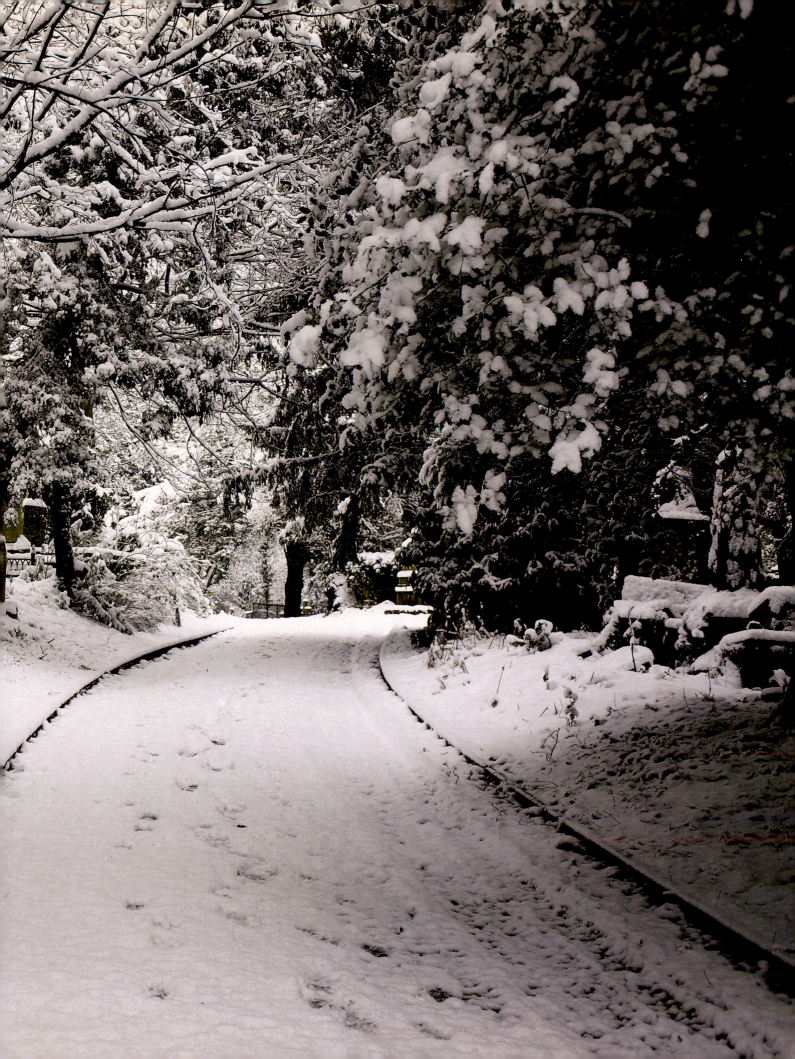

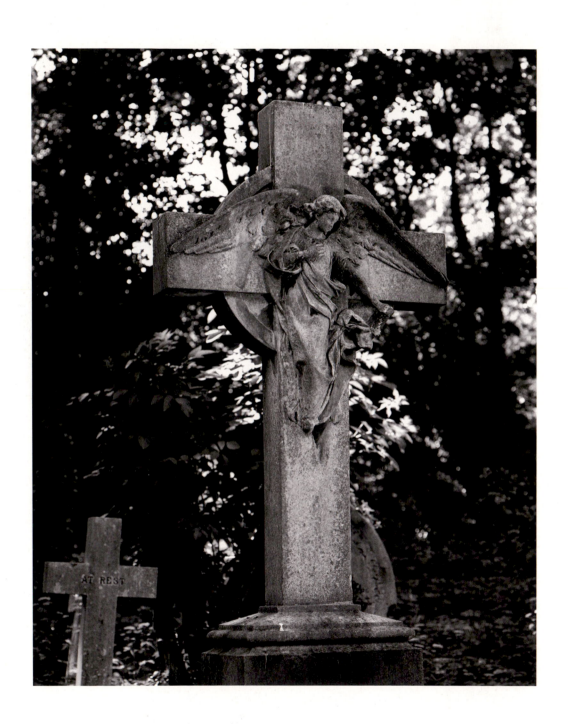

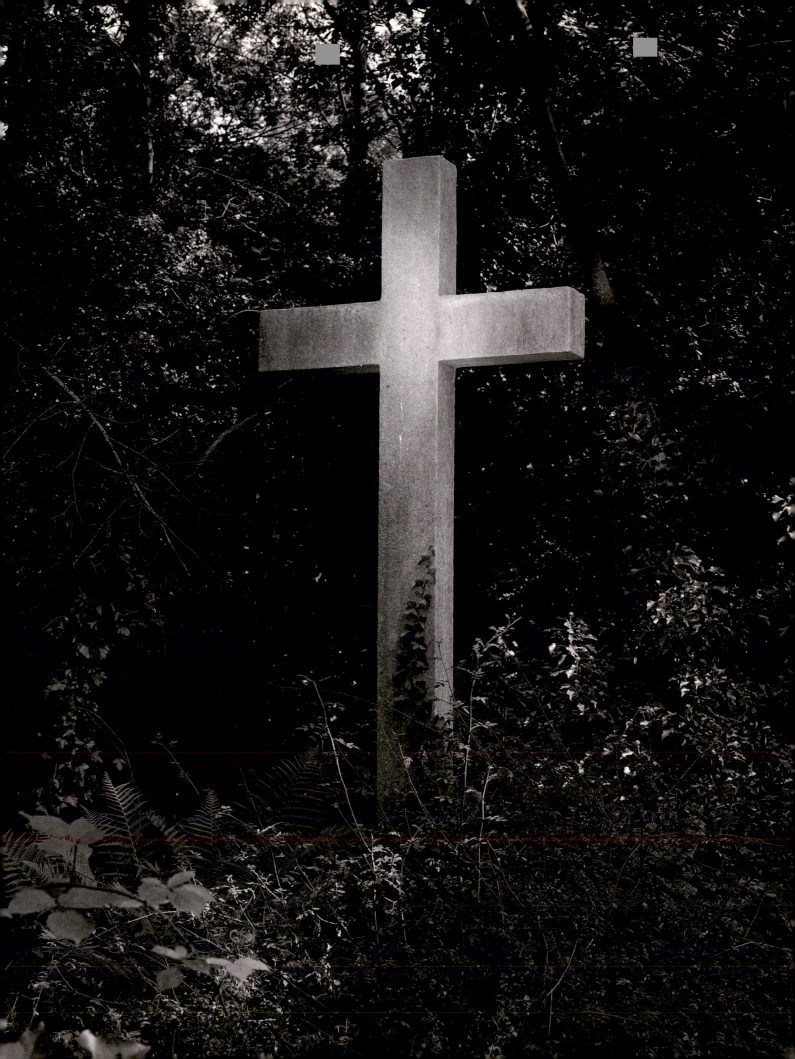

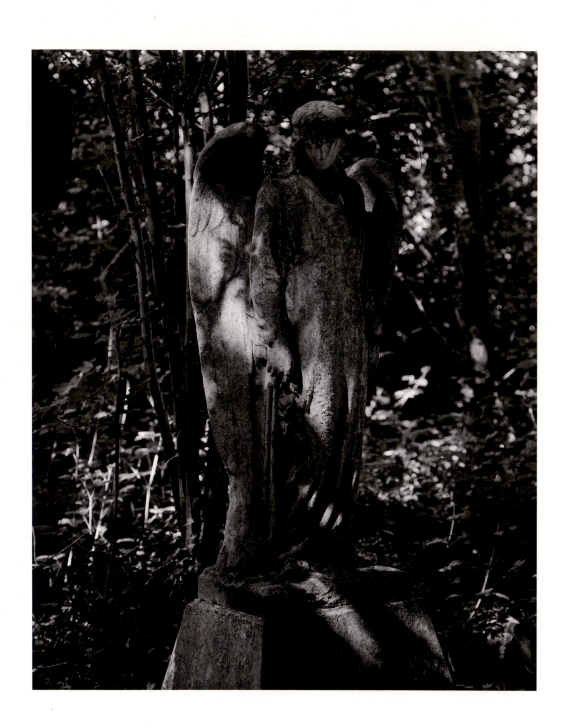

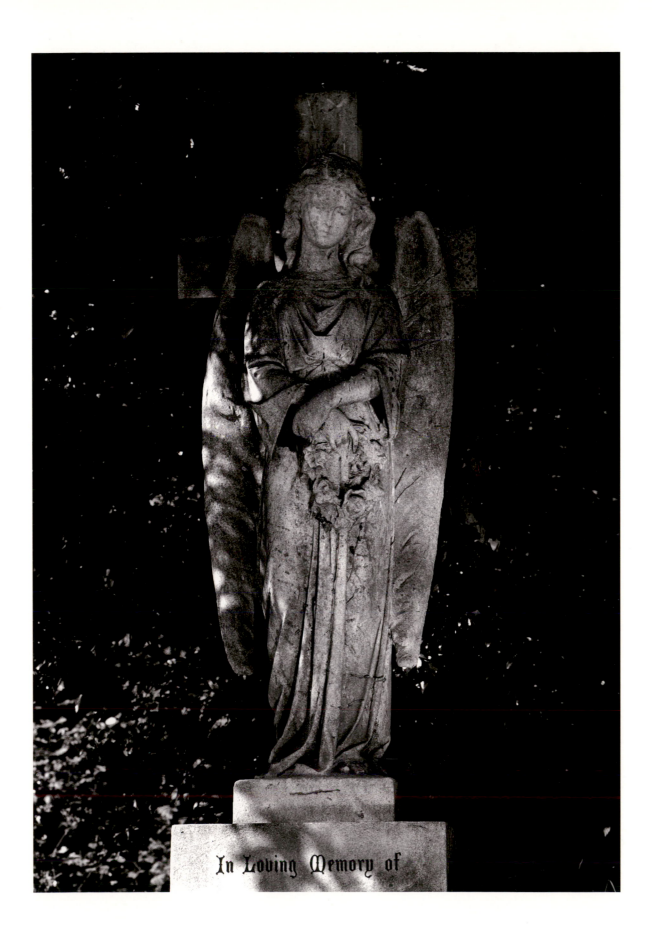

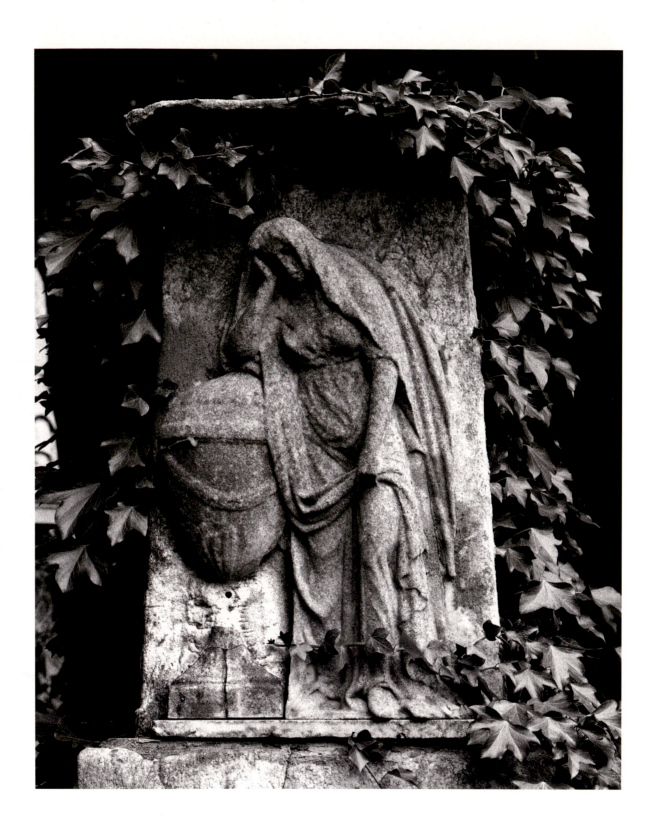

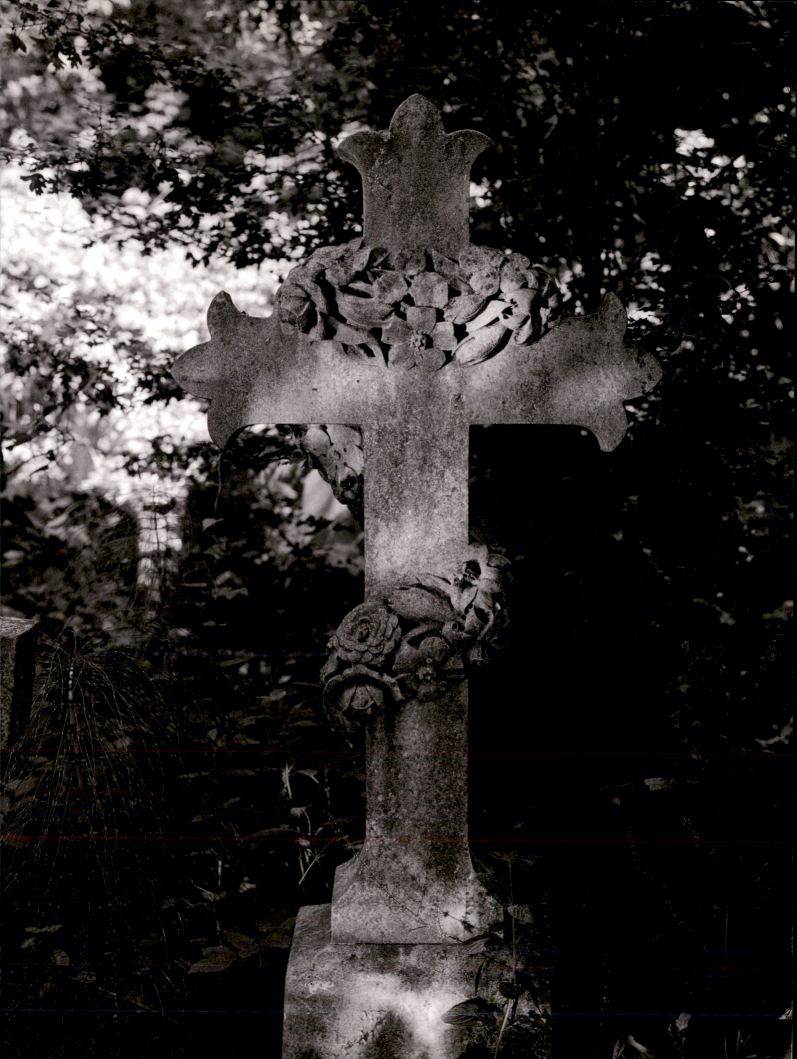

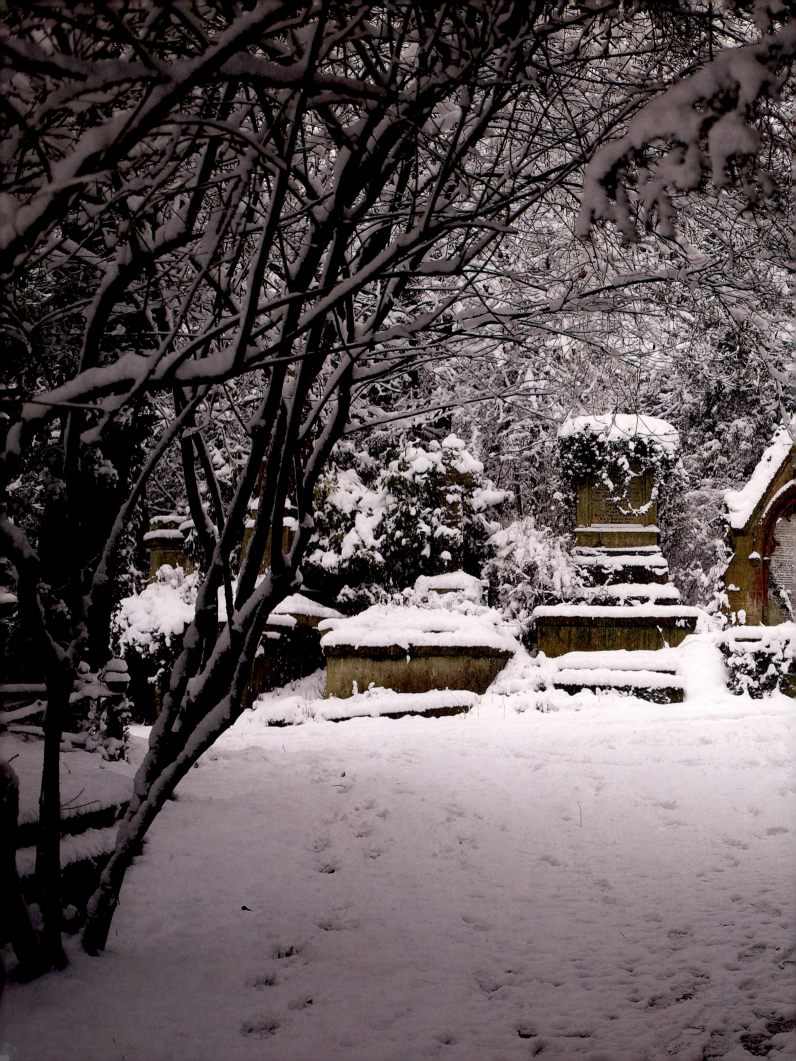

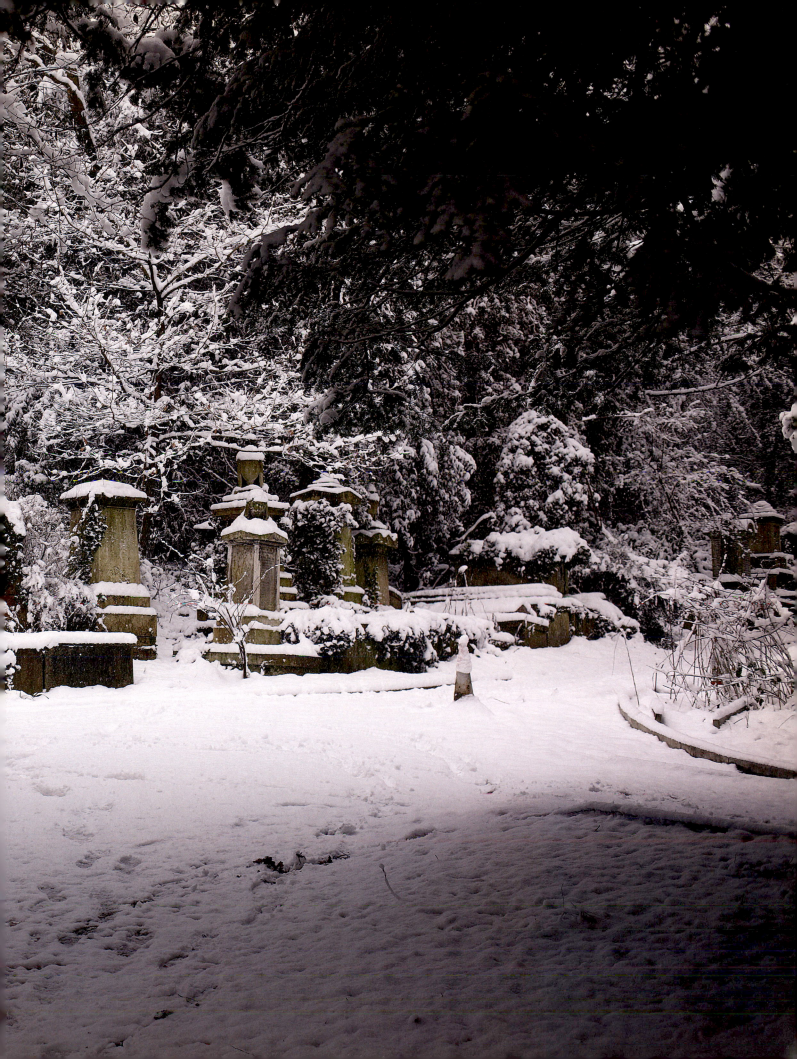

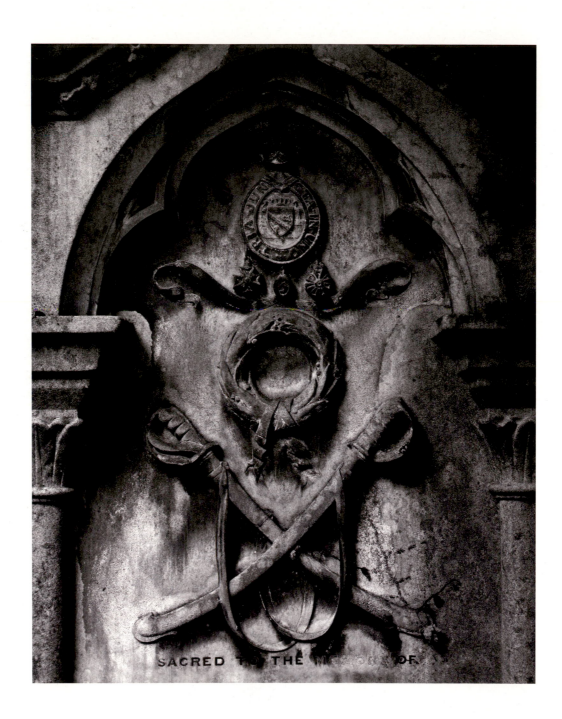

SACRED TO THE MEMORY OF

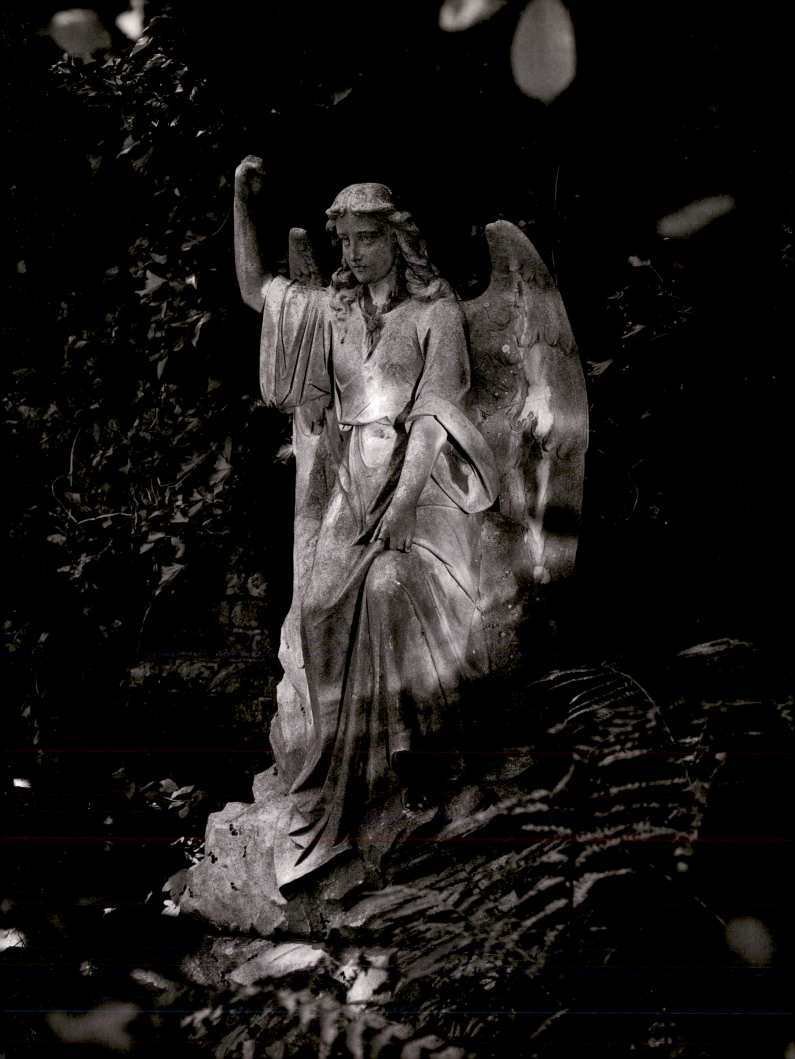

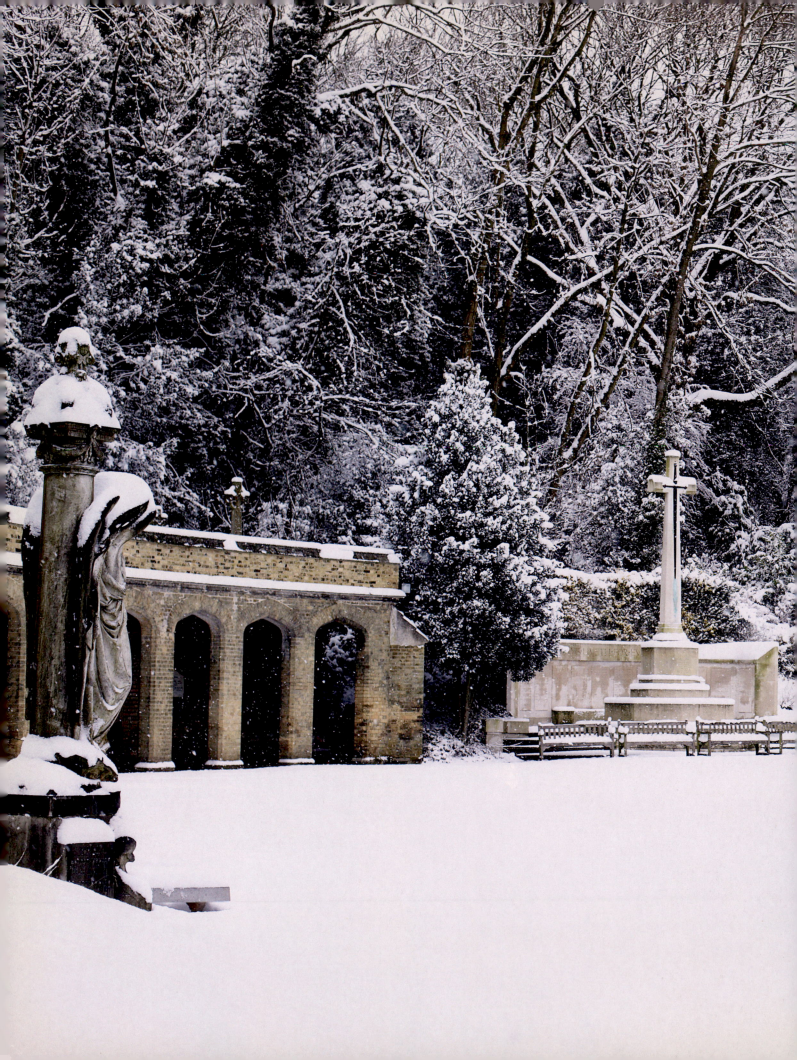

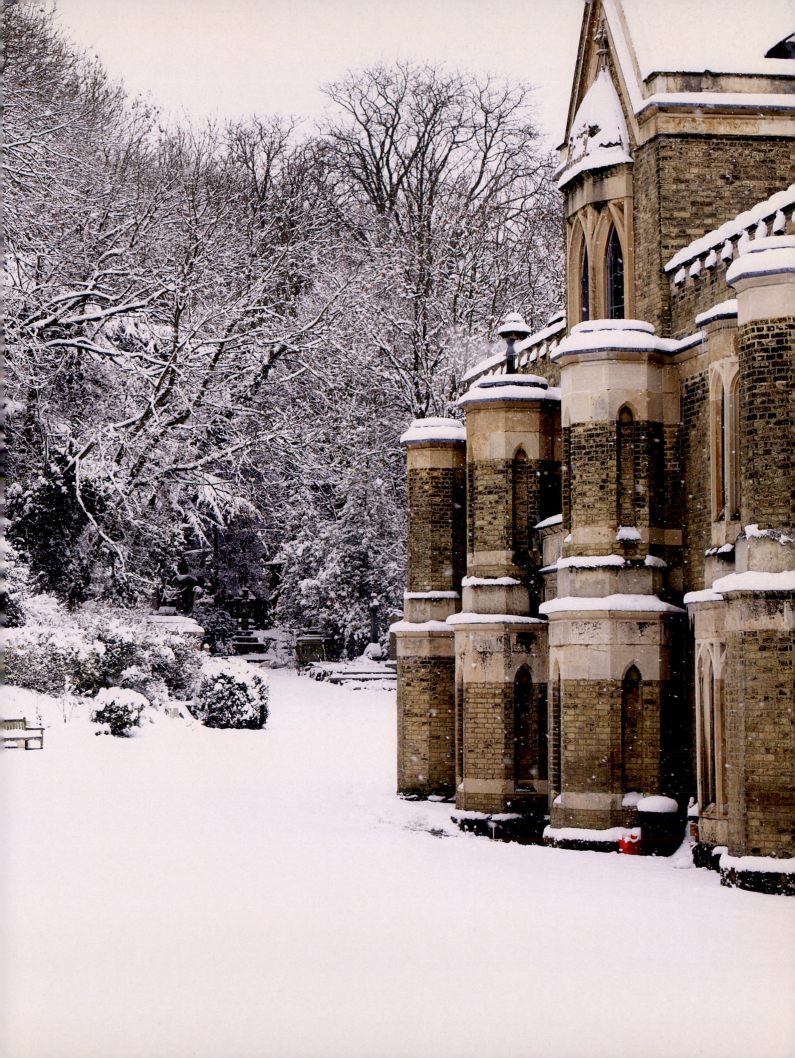

AFTERWORD

FoHC

Friends of Highgate Cemetery

In 1975, inspired by local residents and motivated by The Highgate Society, Friends of Highgate Cemetery (FOHC) was formed with a fanfare of publicity. Initially it aimed, solely by petition and persistence, to gain authority from the then owners for access for grave owners after closure. Later, volunteers were permitted to tackle excess vegetation which throttled monuments, encroached on pathways and endangered movement.

After three and a half decades, and with ownership secured by Friends of Highgate Cemetery Trust, most buildings have had major treatment – usually sensitive conservation with minimal intervention, not restoration – costing several million pounds of privately raised funding. English Heritage has generously helped where its remit has permitted, and there has been one grant from the Heritage Lottery Fund. Three miles of boundary walls have been secured and the Cemetery has been registered as a Grade 1 listed Park.

Highgate is now recognised as one of Europe's significant cemeteries, is regularly used for burials and referred to as a *sacred place of ultimate repose*. Two bishops have remarked that *a place of despair has become a place of hope*.

Jean Pateman

*With thanks to the following patrons whose
generosity has made this book possible*

Mrs Marlena Hellebo

Marsh Christian Trust

John R. Murray Charitable Trust

Ms Audrey Niffenegger

Mrs Jean B. Pateman MBE

Mr & Mrs Bruce Russell

Mr John Swannell

Marianne Lah Swannell

Diana Young Trust